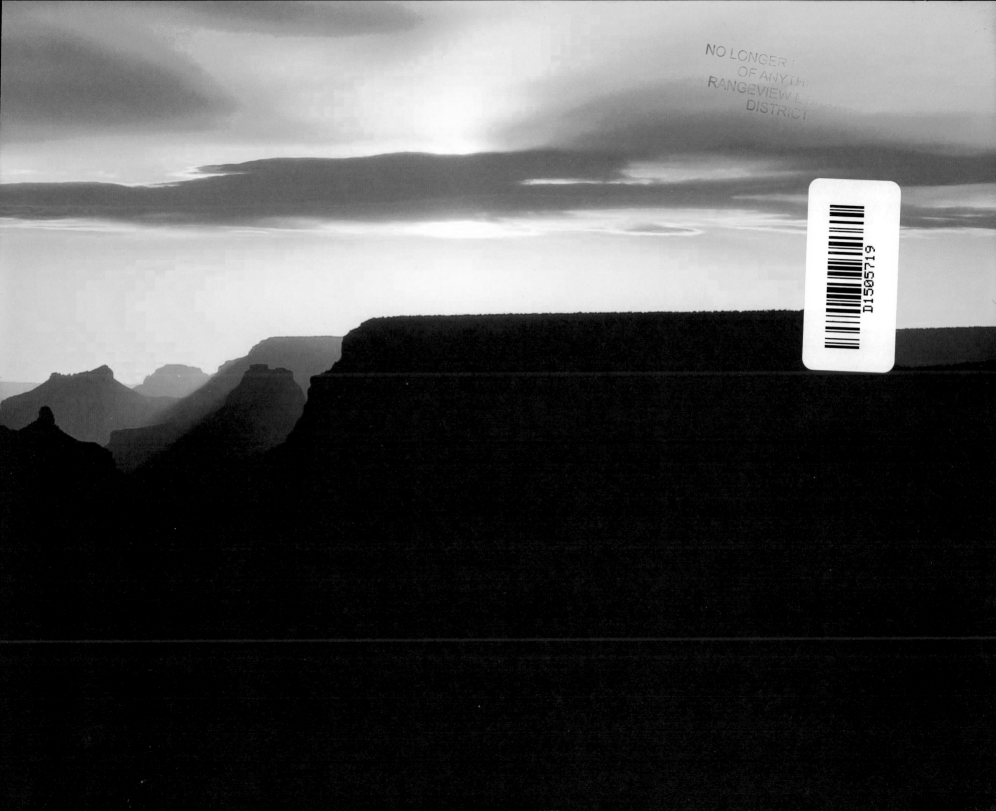

Southwest Reflections
Grand Canyon & The Four Corners

Steve Larese

Schiffer Publishing Ltd®

4880 Lower Valley Road • Atglen, PA 19310

Other Schiffer Books by the Author:
Durango Perspectives. ISBN: 9780764333378. $9.99
Santa Fe Reflections. ISBN: 9780764336539. $24.99

Other Schiffer Books on Related Subjects:
A Journey through Northern Arizona. Victoria Clark. ISBN: 9780764330100. $24.99
Touring the West. Paul & Kathleen Nickens. ISBN: 9780764331107. $24.99
*The Traveling Nature Photographer: A Guide for Exploring the Natural World through
 Photography.* Steven Morello. ISBN: 9780764330551. $29.99

Library of Congress Control Number: 2012933387

Cover and book designed by: Bruce Waters
Type set in Zurich BT

ISBN: 978-0-7643-4093-2
Printed in China

Schiffer Books are available at special discounts for bulk purchases for sales promotions or premiums. Special editions, including personalized covers, corporate imprints, and excerpts can be created in large quantities for special needs. For more information contact the publisher:

Published by Schiffer Publishing Ltd.
4880 Lower Valley Road
Atglen, PA 19310
Phone: (610) 593-1777; Fax: (610) 593-2002
E-mail: Info@schifferbooks.com

For the largest selection of fine reference books on this and related subjects, please visit our website at
www.schifferbooks.com
We are always looking for people to write books on new and related subjects. If you have an idea for a book, please contact use at proposals@schifferbooks.com

This book may be purchased from the publisher.
Please try your bookstore first.
You may write for a free catalog.

In Europe, Schiffer books are distributed by
Bushwood Books
6 Marksbury Ave.
Kew Gardens
Surrey TW9 4JF England
Phone: 44 (0) 20 8392 8585; Fax: 44 (0) 20 8392 9876
E-mail: info@bushwoodbooks.co.uk
Website: www.bushwoodbooks.co.uk

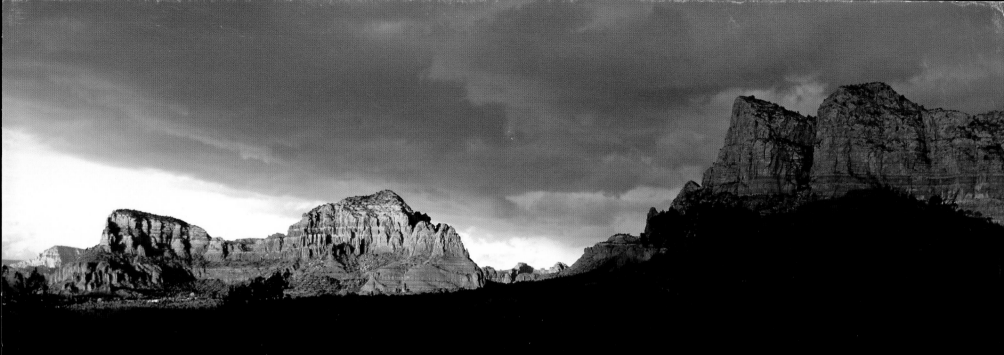

Contents

Introduction

New Mexico, Colorado, Arizona, and Utah together make the Four Corners region, the only point in the United States where four states meet. This sun-drenched land is soaked in Native American history, as well as the future of the Navajo, Ute, and Hopi tribes. The Four Corners have entered American mythology through the Westerns of John Ford, the mystery novels of Tony Hillerman, and countless images that have tried to capture its mercurial beauty.

Exploring this region takes a lifetime, but the rewards come quickly. From Albuquerque, the Grand Canyon is a 420-mile drive west on I-40 to Williams, Arizona, then north on AZ 64 (about a seven-hour drive). Give yourself time to explore Gallup, New Mexico, the Petrified Forest and Painted Desert, and the charming city of Flagstaff, Arizona. From Phoenix, it's a four-hour drive north on I-17 to I-40 on to Williams, passing Sedona and Flagstaff on the way.

To drive into the heart of the Four Corners from Albuquerque, take US 550 northwest to Farmington, about 3.5 hours (200 miles) away. The landscape soon takes on an otherworldly feel, with red and white mesas crisp against a dark blue sky. Along the way, you'll pass **Chaco Canyon National Historical Park**, the epicenter of the ancient Pueblo world. Navajo hogans, traditional structures used for ceremonies, begin to dot the country as you near the Navajo Nation. The towns of Bloomfield and Aztec speak to Anglo farming settlement here in the 1800s, and the nearby **Salmon and Aztec ruins** underscore that Native Americans have long called this land home. From Aztec, head north to Durango and the cliff dwellings at **Mesa Verde National Park**, or continue west from Farmington on US 64, where you'll see majestic **Ship Rock** rise in the distance.

Your tour of the Four Corners doesn't recognize state lines. A photo of family members stretched into four states is a must at the **Four Corners Monument**, which is reached via US 160 that travels northeast from Teec Nos Poc in Arizona. Taking US 160 west to Kayenta will bring you to **Monument Valley**, with its iconic formations (Kayenta is about 100 miles from Shiprock). At Kayenta, take scenic US 163 north to the monument entrance ($5 cash per vehicle entry fee). About nine miles west of Kayenta on US 160, the ancestral puebloan ruins at **Navajo National Monument** are breathtaking.

From Monument Valley, you can continue north on US 163 into Utah, passing **Gooseneck State Park** and arriving at Mexican Hat. UT 261 north leads to **Natural Bridges National Monument**, or continue along US 163 into Bluff. From here, travel north for about nine miles to UT 262, then east for eighteen miles to reach **Hovenweep National Monument** in Colorado. Explore these ancestral puebloan ruins, then circle back to Cortez near Mesa Verde via US 491.

If from Shiprock, New Mexico, you take US 491 south (formerly US 666) for six miles, then Navajo 13, you drive past Mitten Rock into Red Valley. From here, continue on Navajo 13 for about twenty-two miles until you intersect Navajo 12. Head south for seven miles, and you will drive into **Canyon de Chelly National Monument**, where ruins hide amongst the cliffs that the Navajos sought refuge in during the Kit Carson-led campaign of 1864. From Canyon de Chelly, you can continue south to I-40, which will return you to Albuquerque, passing through Gallup. Exploring America's Four Corners can be addicting, and with so much to see and do, it's hard to know when to head home.

The photos in this book offer just a brief glimpse into the rich culture, history, and zen-like balance of this ancient land. I hope it in some small way encourages you to set off on your own adventure, whether it's a road trip to Monument Valley or hiking below the rim of the Grand Canyon. Most importantly, I hope you meet some of the people who call this land home, and come to appreciate the importance it holds for them. Perhaps no words better express this sentiment than those spoken during the Navajo Beauty Way Ceremony:

The Navajo Beauty Way Ceremony

In beauty may I walk
All day long may I walk
Through the returning seasons may I walk
Beautifully I will possess again
Beautifully birds
Beautifully joyful birds
On the trail marked with pollen may I walk
With grasshoppers about my feet may I walk
With dew about my feet may I walk
With beauty may I walk
With beauty before me may I walk
With beauty behind me may I walk
With beauty above me may I walk
With beauty all around me may I walk
In old age, wandering on a trail of beauty, lively, may I walk
In old age, wandering on a trail of beauty, living again, may I walk
It is finished in beauty
It is finished in beauty

Reflections

Grand Canyon National Park became a national park in 1919. In 1903, President Theodore Roosevelt said "The Grand Canyon fills me with awe. It is beyond comparison–beyond description; absolutely unparalleled throughout the wide world Let this great wonder of nature remain as it now is. Do nothing to mar its grandeur, sublimity, and loveliness. You cannot improve on it. But what you can do is to keep it for your children, your children's children, and all who come after you, as the one great sight which every American should see."

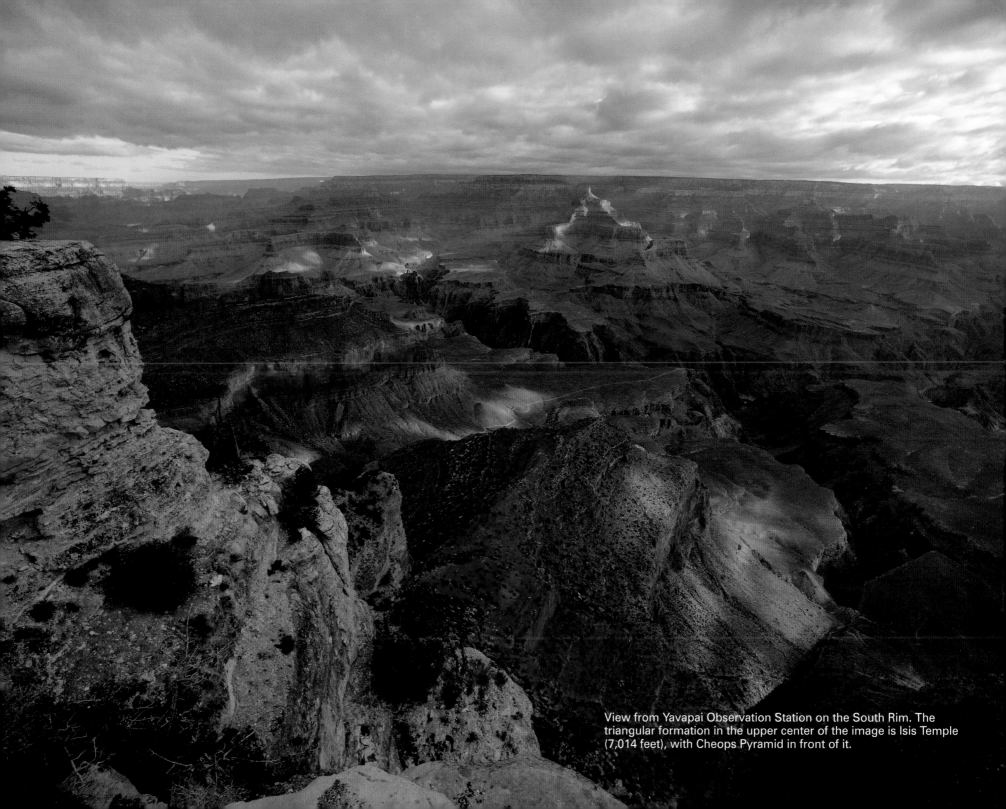

View from Yavapai Observation Station on the South Rim. The triangular formation in the upper center of the image is Isis Temple (7,014 feet), with Cheops Pyramid in front of it.

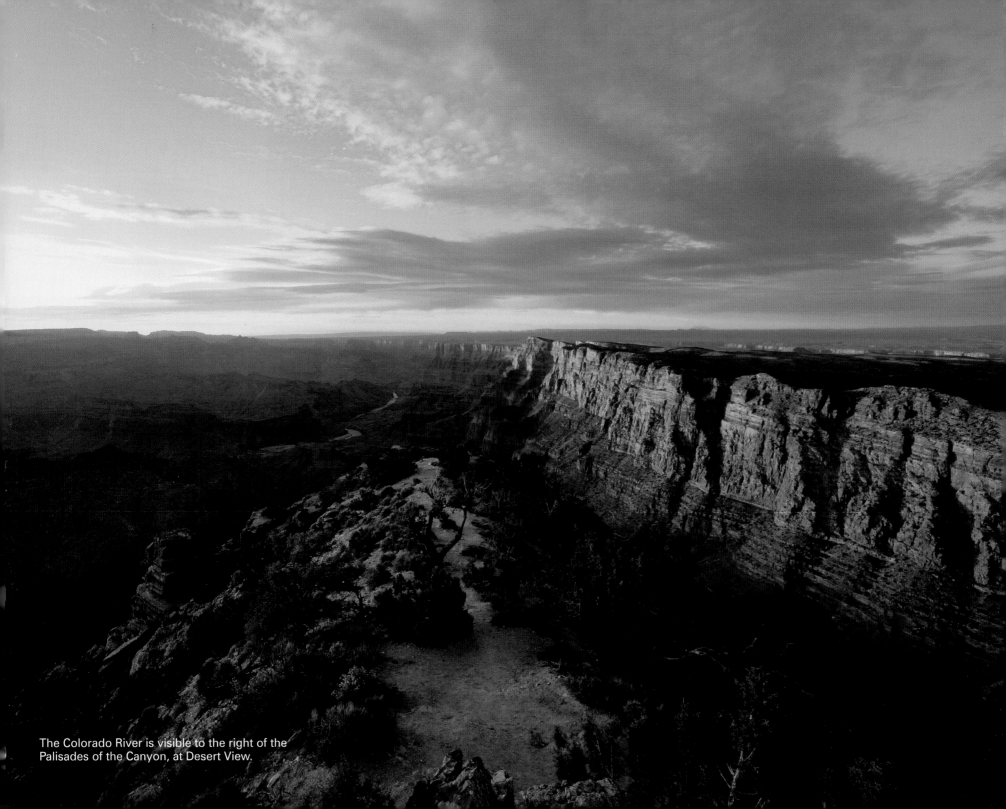

The Colorado River is visible to the right of the
Palisades of the Canyon, at Desert View.

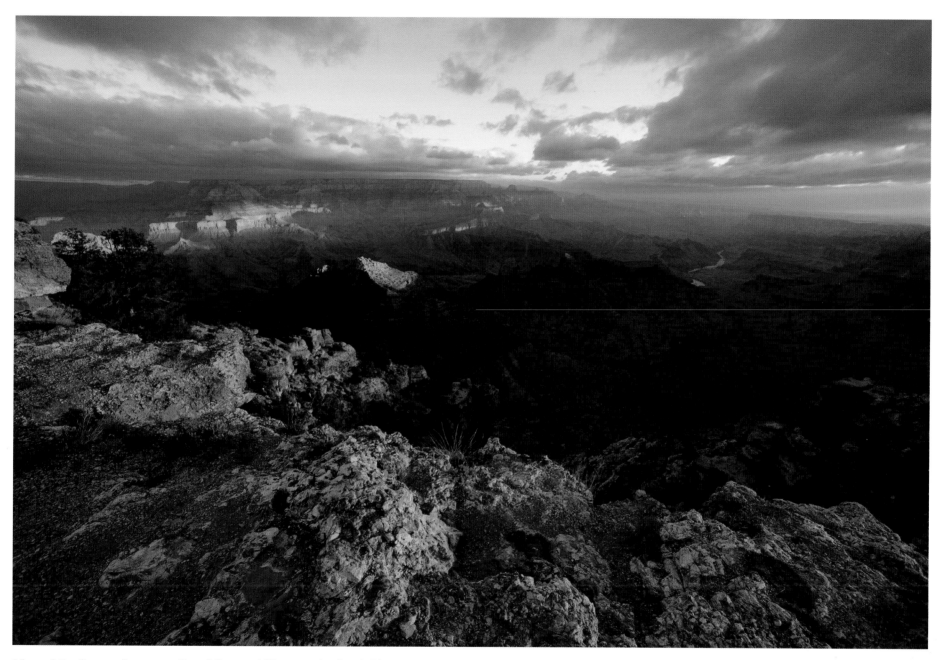

View of the Canyon from near Grand Canyon Village on the South Rim, where the park's historic hotels and most amenities are located. Grand Canyon National Park is 277 miles long and eighteen miles across at its widest between the North and South Rims. It is one mile at its deepest.

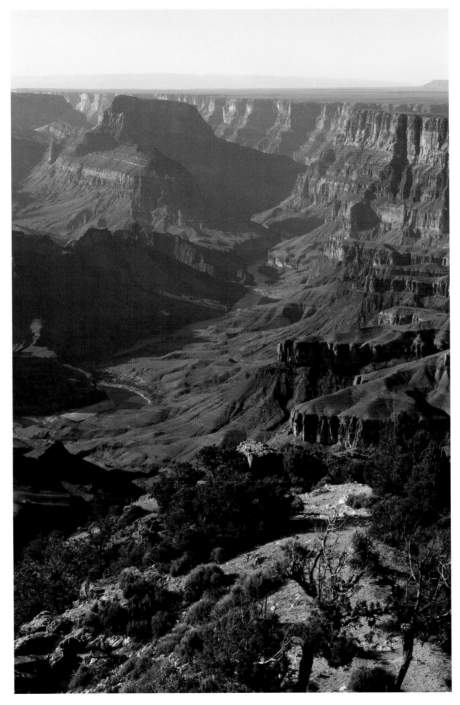

Rock strata carved by the Colorado River through the
Kaibab Plateau dates to 2-billion-years old.

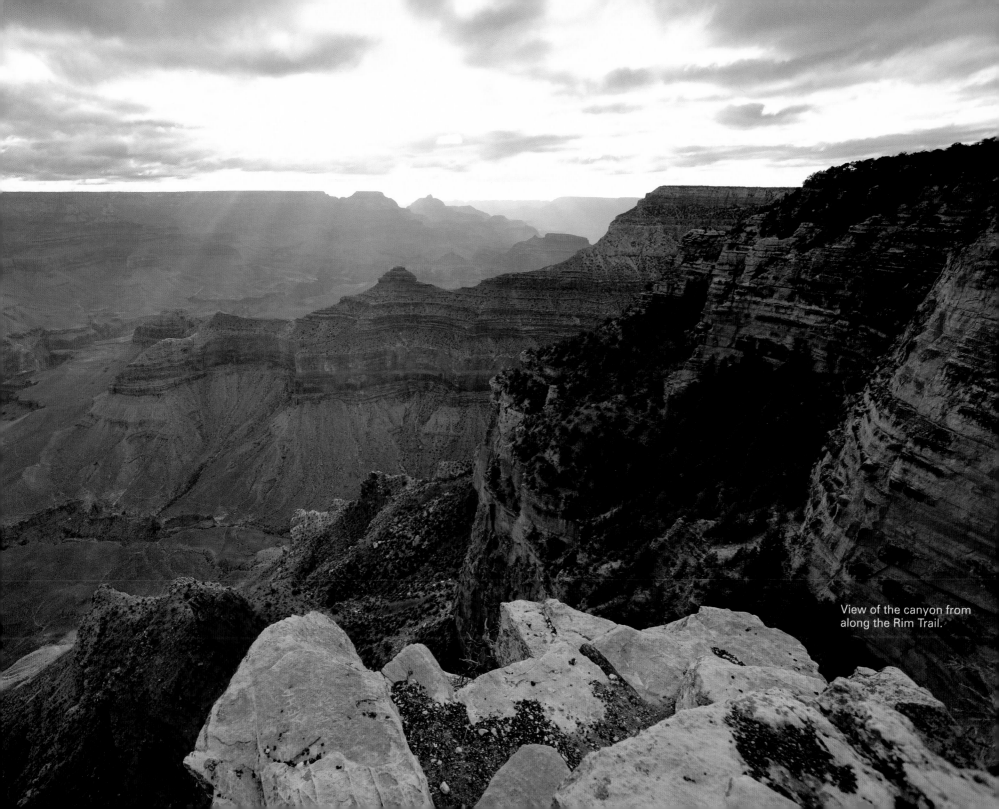

View of the canyon from along the Rim Trail.

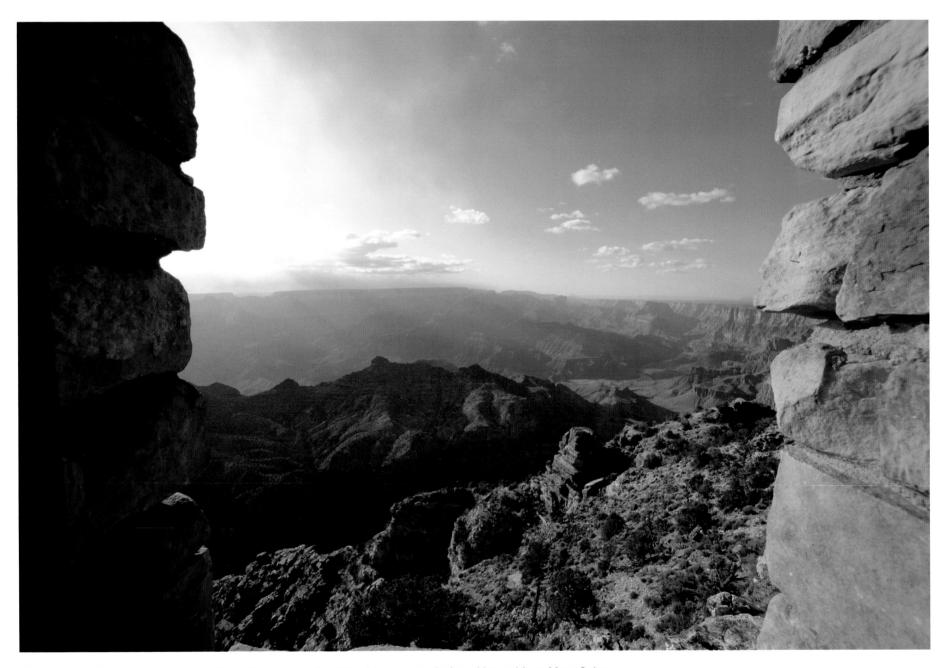

View from the Watchtower at Desert View. The seventy-foot Watchtower was designed by architect Mary Colter and built in 1932 for the Fred Harvey Company. It was inspired by ancient puebloan architecture. Colter designed many of the buildings still in use at the park, including Lookout Studio, Bright Angel Lodge and Phantom Ranch at the bottom of the canyon.

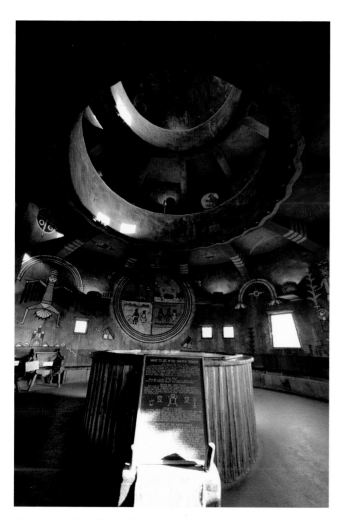

Hopi artist Fred Kabotie painted the murals that grace the interior of the Watchtower.

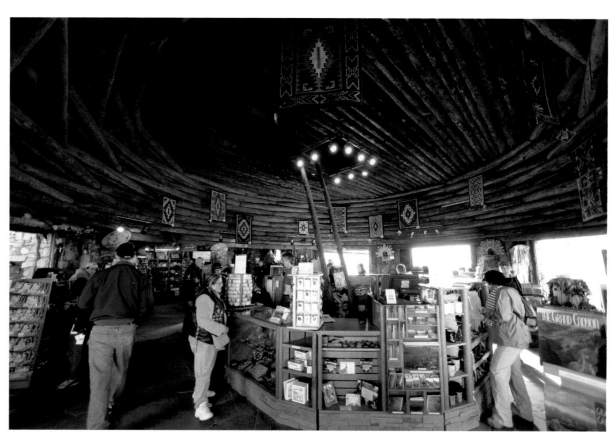

The historic gift shop on the Watchtower's first floor.

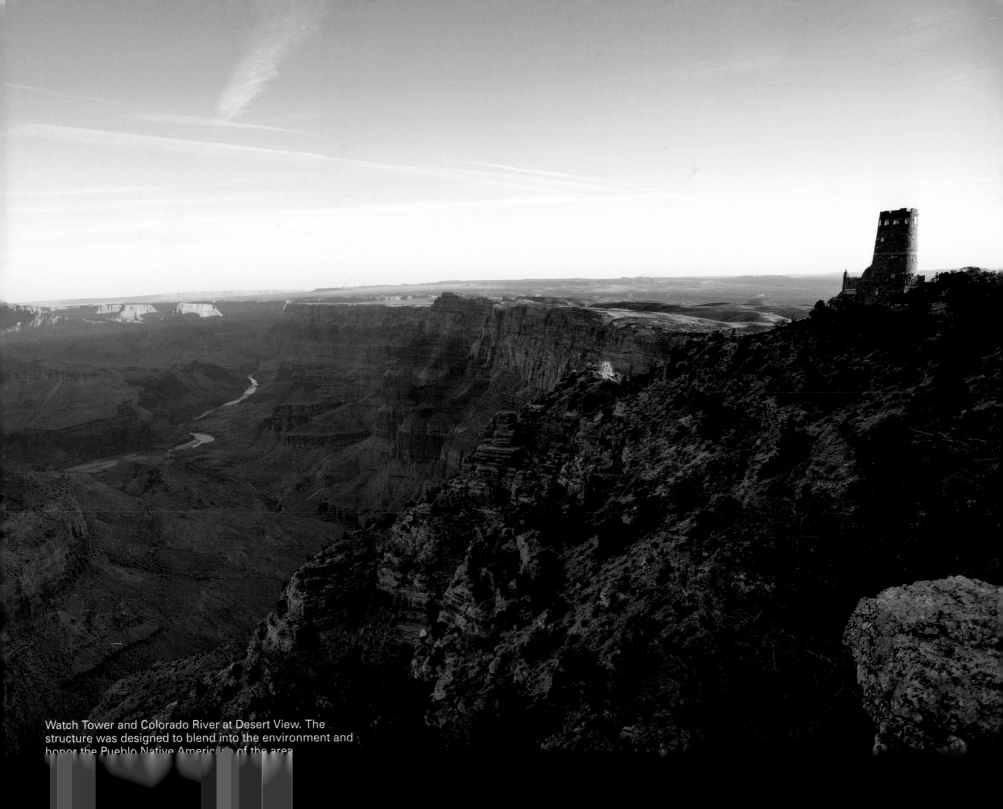

Watch Tower and Colorado River at Desert View. The structure was designed to blend into the environment and honor the Pueblo Native Americans of the area.

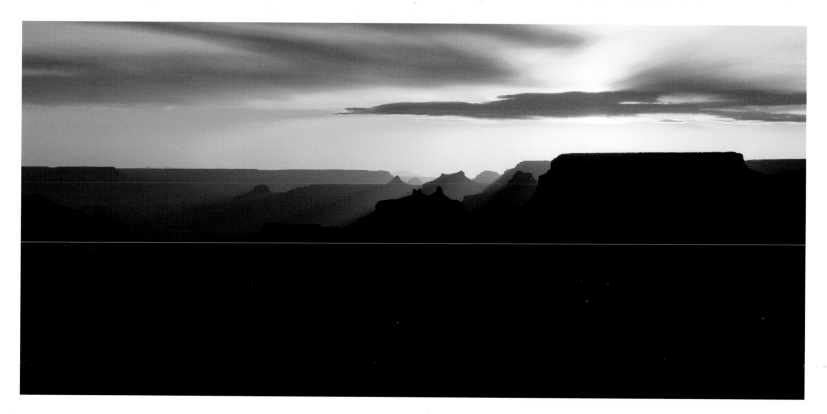

Sunsets from Desert View.

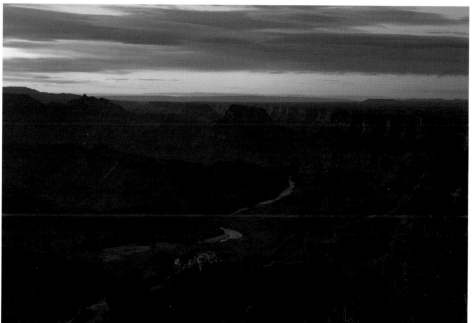

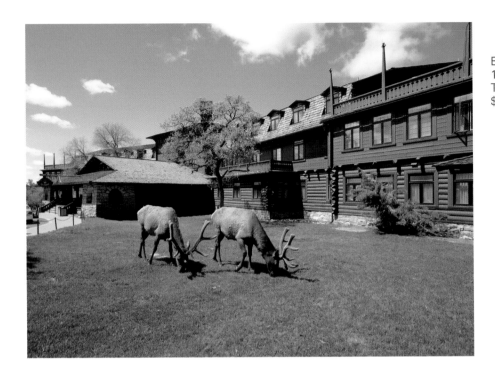

Elk graze at El Tovar at Grand Canyon Village. The hotel opened in 1905 and was built by the Fred Harvey Company for the Atchison, Topeka & Santa Fe Railroad to board tourists arriving by train. It cost $250,000 to build.

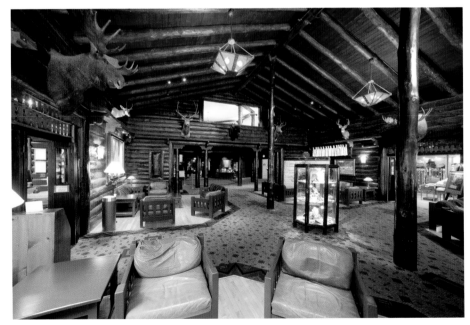

Architect Mary Colter designed much of El Tovar's interior. The hotel was named for Don Pedro de Tovar, a Spanish conquistador in Coronado's 1540 expedition. Until the hotel was built, tourists arriving by train from Flagstaff found only tents along the rim.

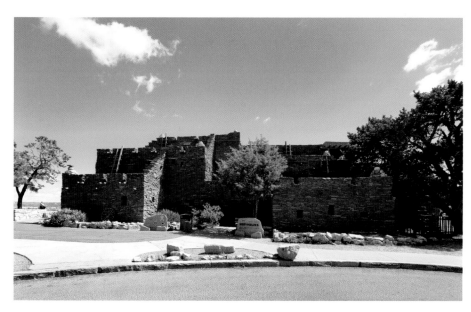

The Hopi House was designed by Mary Colter as a gift shop for Fred Harvey, and was built mostly by Hopis. It is modeled after dwellings found in the Hopi village of Old Oraibi.

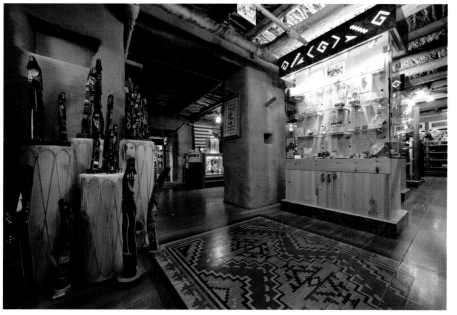

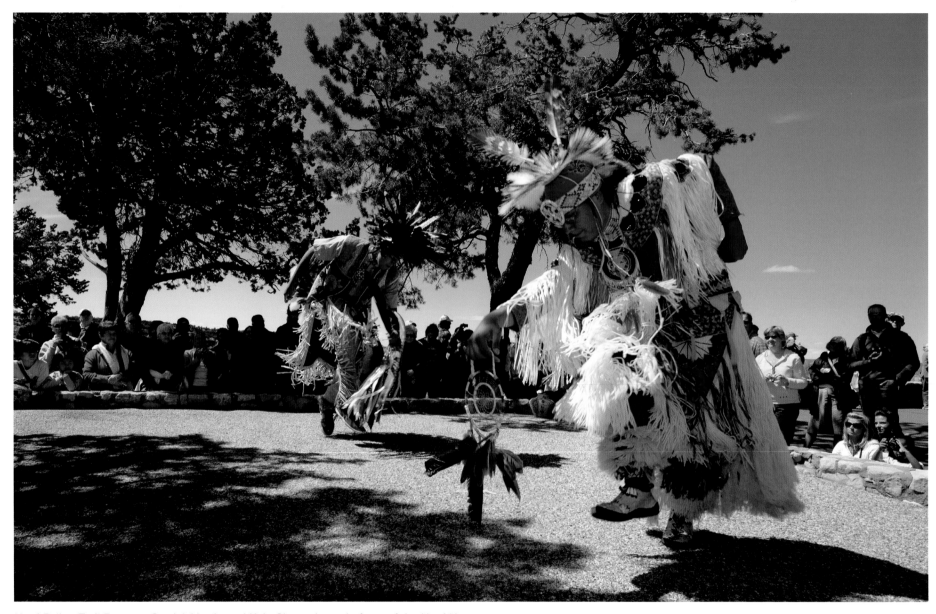

Hopi Pollen Trail Dancers Garrick Yazzie and Kyle Chase dance in front of the Hopi House.

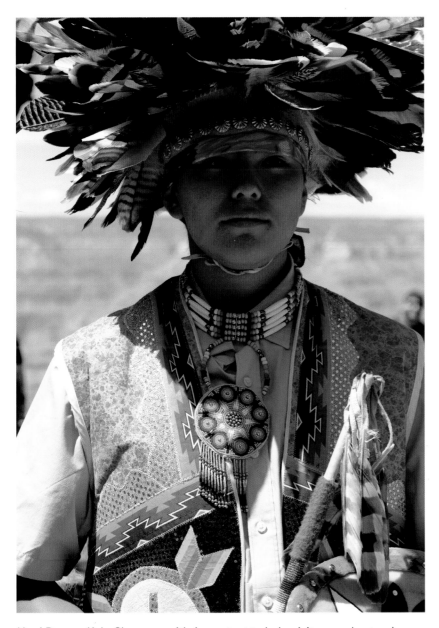

Hopi Dancer Kyle Chase says it's important to help visitors understand the Hopi connection to the Grand Canyon. Hopi beliefs say their people emerged into this world through an opening in the Grand Canyon, called the *Sipapuni*. The Hopi of Arizona and other pueblo tribes throughout New Mexico incorporate *sipapus,* small ceremonial holes, in the floor of religious structures, called *kivas,* to symbolize this.

The ancient village of Tusayan was built by ancestral puebloans in approximately A.D. 1185. The ruin is one of 4,300 archeological sites found within Grand Canyon National Park.

The Grand Canyon Railway arrived at the Grand Canyon in 1901, and was the only practical way for tourists to visit the Grand Canyon at the time. The $3.95, 65-mile train ride replaced the $15 stagecoach ride from Flagstaff. The train is still an excellent way to visit the Grand Canyon; visit www.thetrain.com for more information.

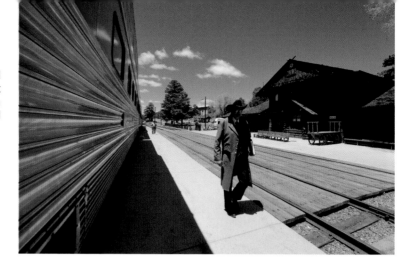

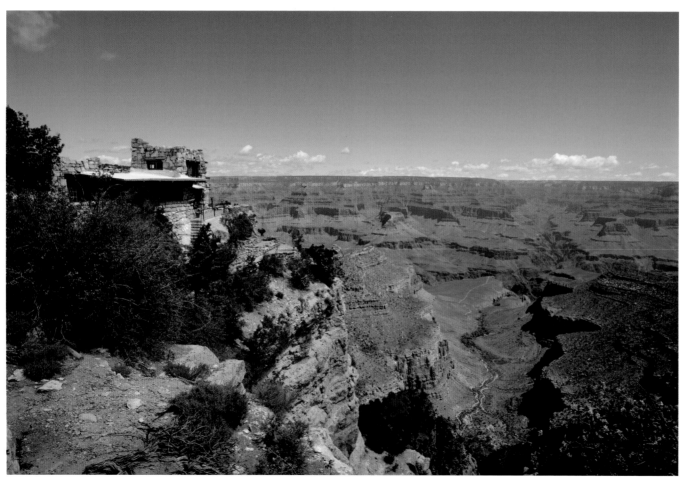

Lookout Studio was built in 1914 by the Santa Fe Railway as a photography studio to compete with the nearby Kolb Studio. Tourist riding mules into the canyon could pay for a photo of themselves. It was designed by Mary Colter.

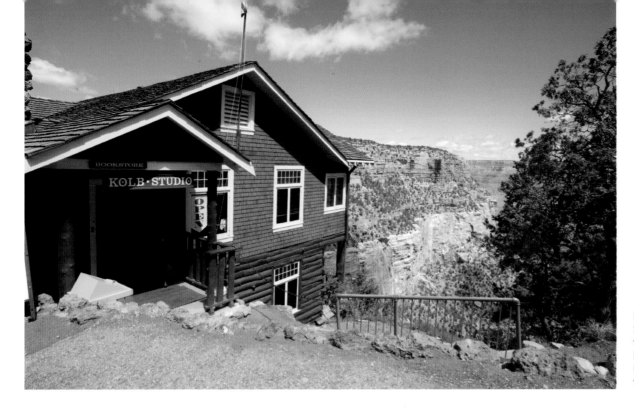

Emery and Ellsworth Kolb built their Kolb Studio in 1904. They would photograph tourists riding mules into the canyon, rush back to develop and print the glass plate, and have photographs ready for purchase by the time the tourists returned.

Today the Kolb Studio hosts a gallery featuring Grand Canyon art, operated by the Grand Canyon Association.

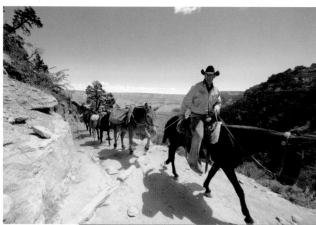

Mule trains are the main method for ferrying supplies to and from Phantom Ranch at the canyon's bottom. The other method is helicopter.

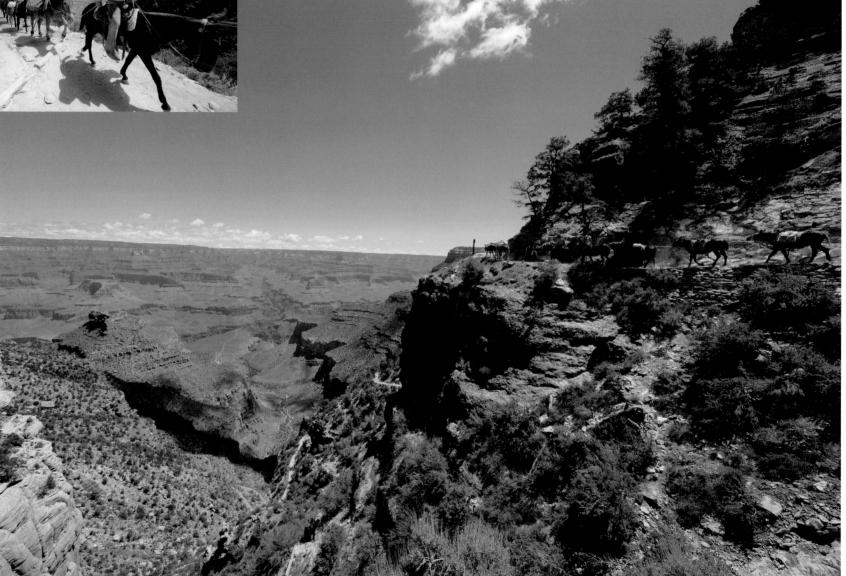

Mules descend Bright Angel Trail. A century ago, miners and prospectors realized there was easier money to be made by taking tourists into the canyon. Today, several lengths of trips are available, from a few hours to overnight journeys to Phantom Ranch.

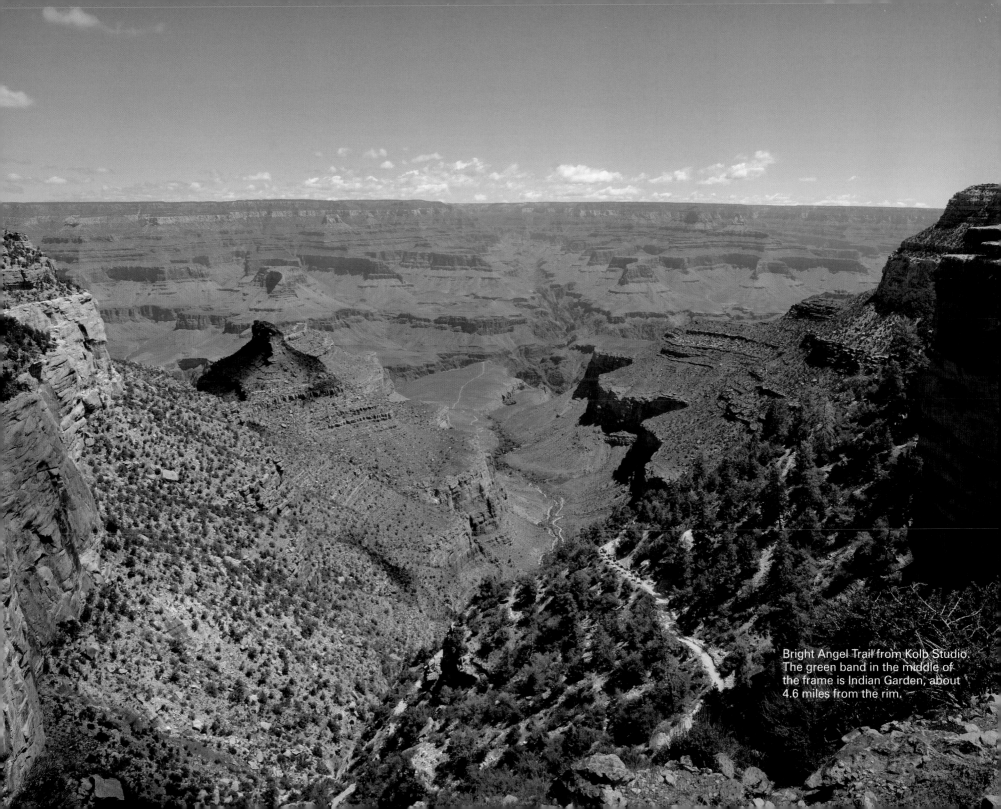

Bright Angel Trail from Kolb Studio. The green band in the middle of the frame is Indian Garden, about 4.6 miles from the rim.

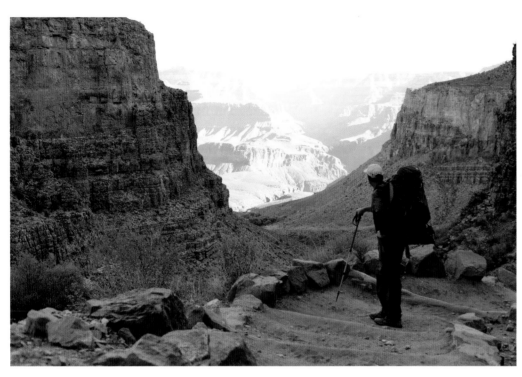

Every year nearly five million people from all over the world travel to see the Grand Canyon, mostly from the South Rim. Fewer than 50,000 hike into the canyon.

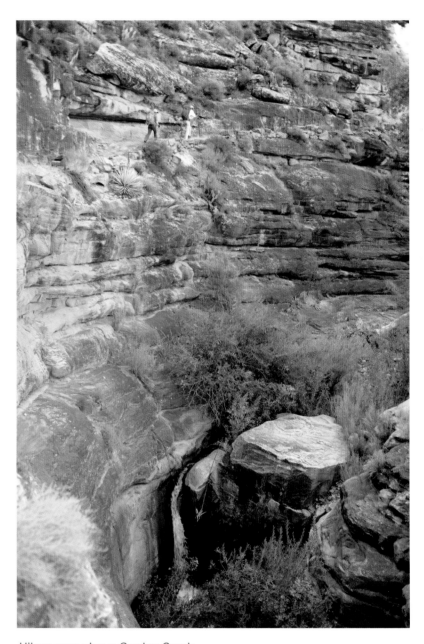

Hikers pass above Garden Creek.

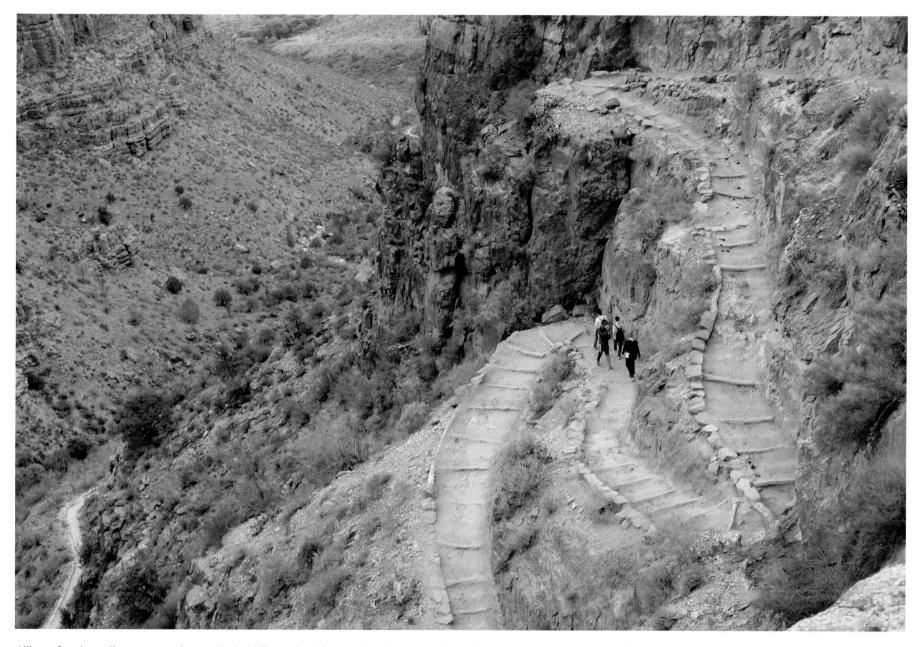

Hikes of various distances can be made, but hikers should remember it takes twice as long to come up than to go down and plan accordingly. Every year five to ten people perish from heat exhaustion in the Grand Canyon, and hundreds are treated for heat-related conditions.

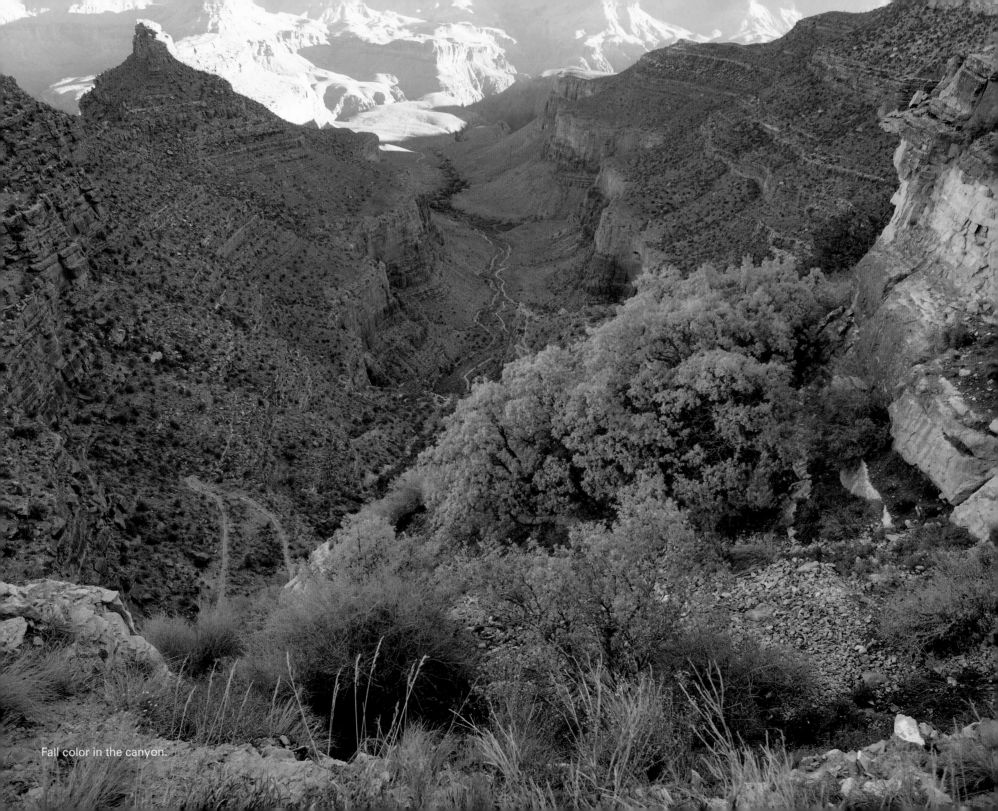

Fall color in the canyon.

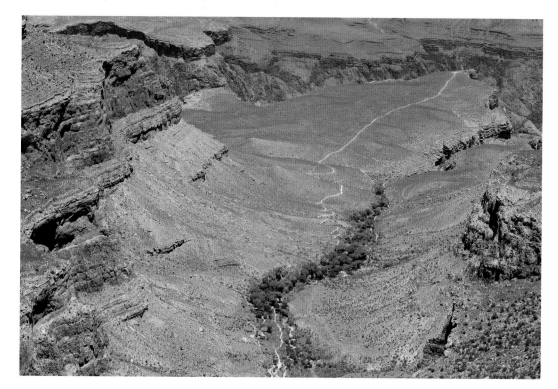

Indian Garden, 4.6 miles from the South Rim on Bright Angel Trail, is an oasis that offers an excellent day-hike destination, overnight camping with reservations, or a rest stop on the way to Phantom Ranch.

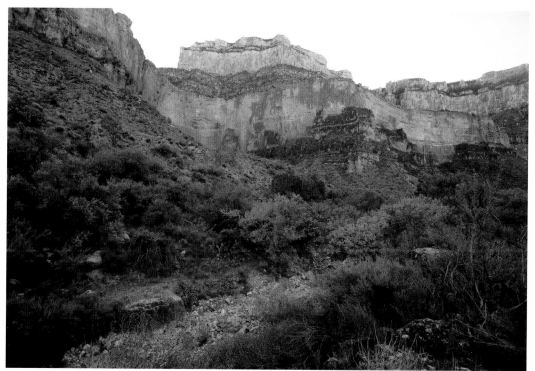

Indian Garden is an oasis along Bright Angel Trail, with a riparian area of willows, cottonwoods, mesquite, and redbuds. There are restrooms, water, and a campground here, and at 4.6 miles from the rim, Indian Garden makes a good destination for a day hike.

Garden Creek flows year-round from the rim to the Colorado River. It is a gathering of natural springs.

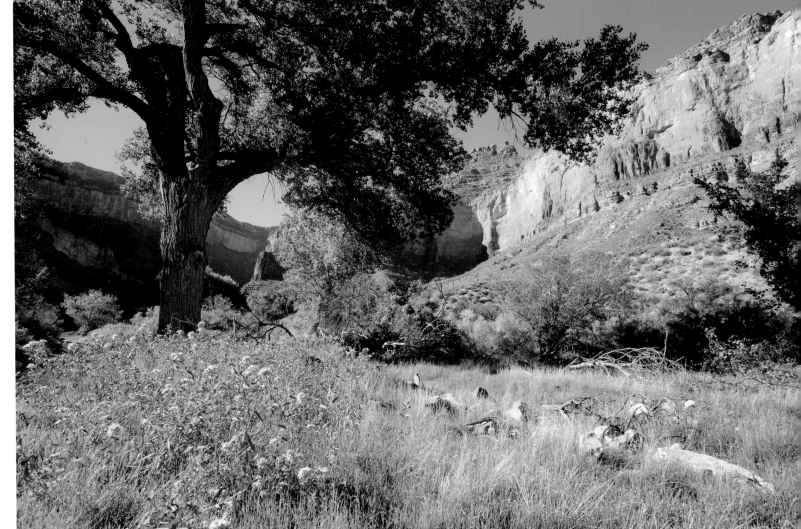

Indian Garden contradicts the Grand Canyon's otherwise rugged and harsh terrain.

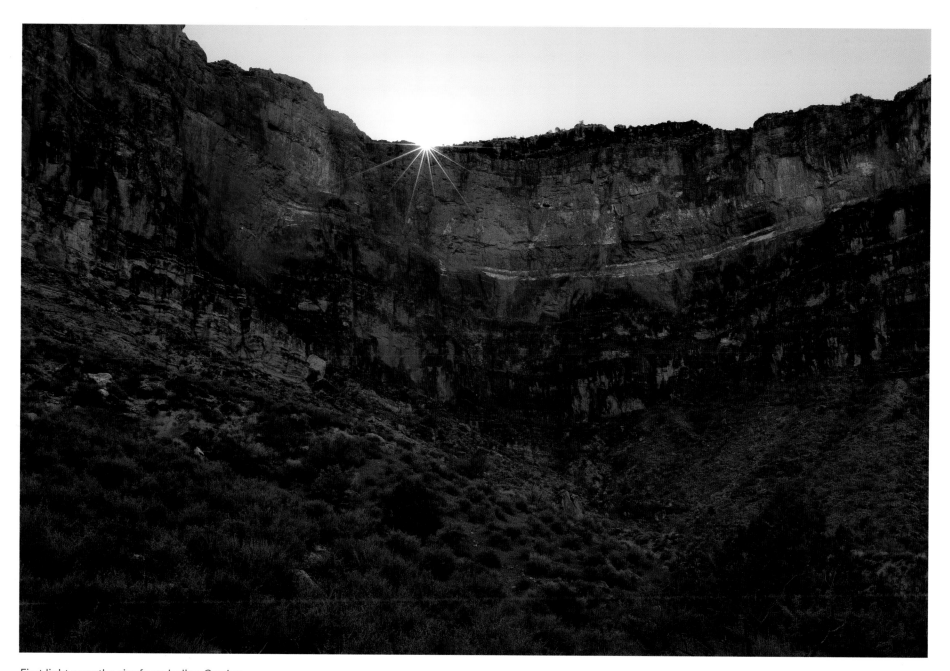

First light over the rim from Indian Garden.

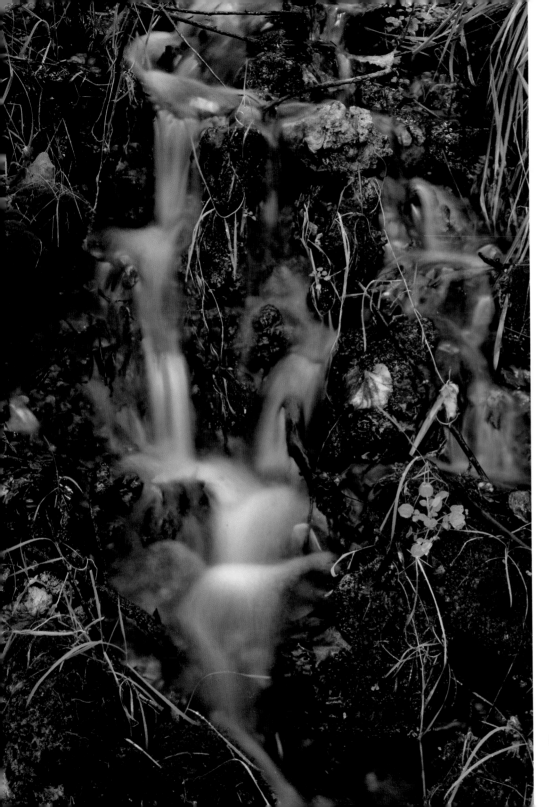

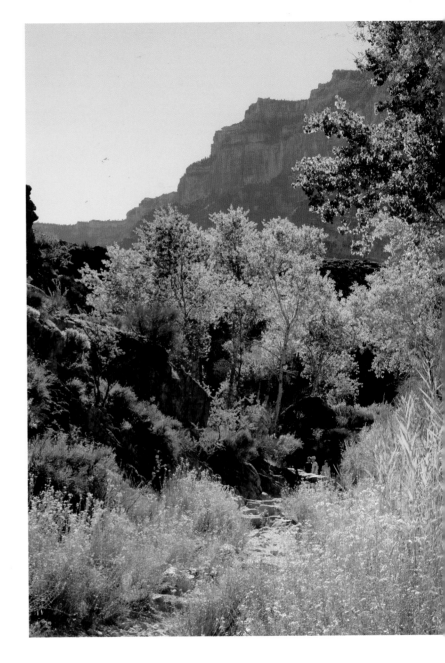

Garden Creek waterfall.

Fall cottonwoods and willows are backlit at Indian Garden.

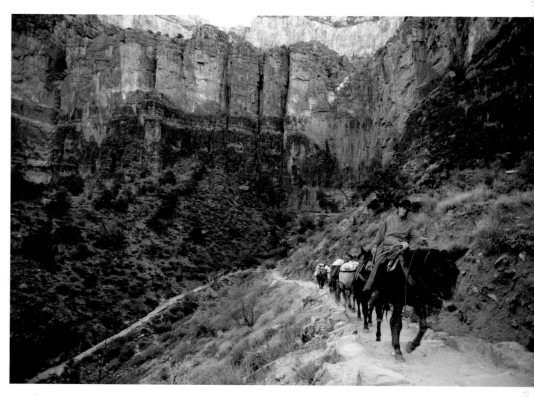

A mule train comes up Bright Angel Trail. Hikers must yield to the trains, and are asked not to move quickly or otherwise spook the mules.

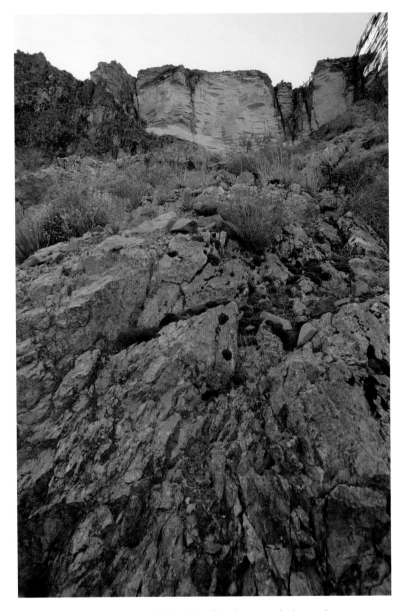

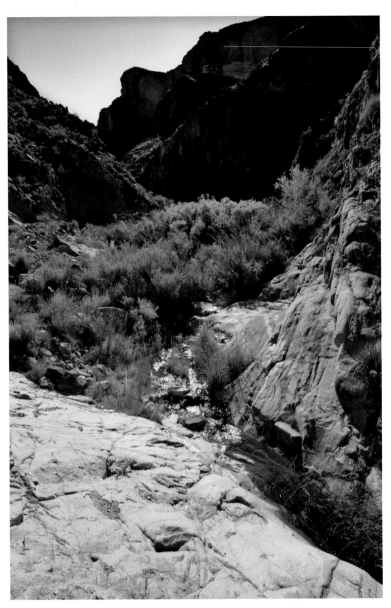

Pink granite in the canyon's interior. Sandstone, shale, and limestone are other common rocks found in the canyon. Looking into the canyon is to look almost two billion years into the Earth's geological history. The white band of rock strata near the top of the ridge is 275 million-year-old Coconino Sandstone. The bright red strata near the middle is 340 million-year-old Redwall Limestone. The rocks at the bottom closest to the river are 1.8 billion-year-old Vishnu Basement Rocks.

Precious water creates a riparian area near the Colorado River.

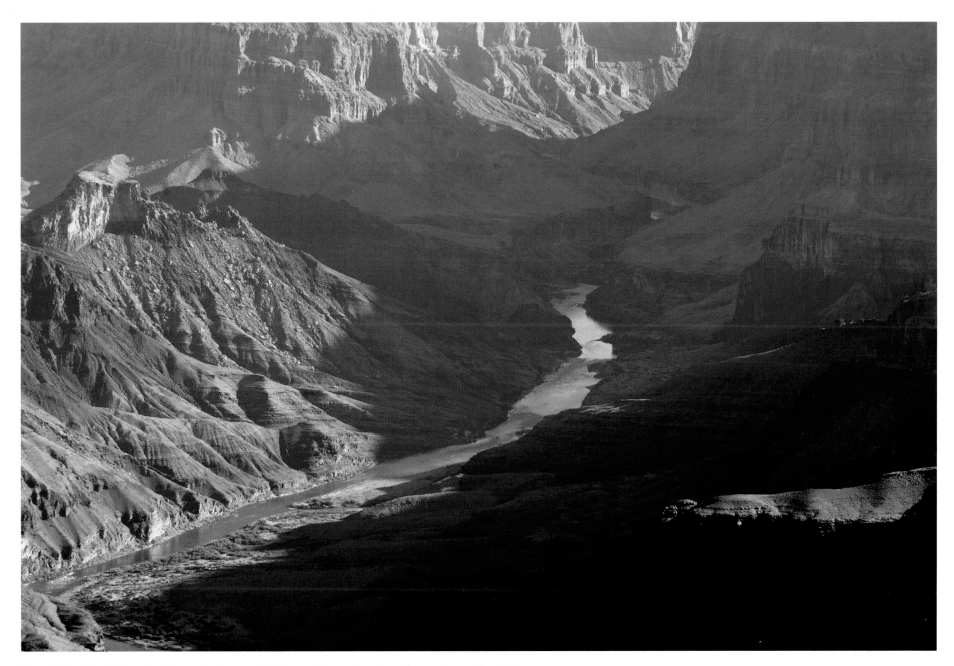

The sight of the Colorado River after hours of hiking quickens the step of travelers to the bottom.

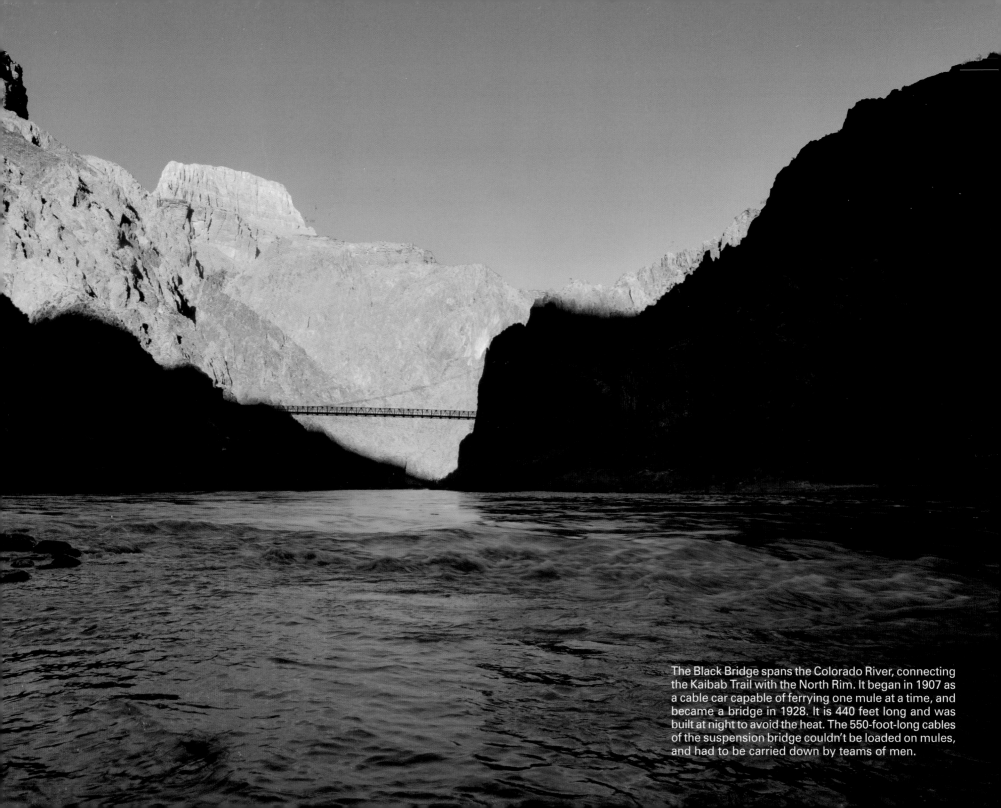

The Black Bridge spans the Colorado River, connecting the Kaibab Trail with the North Rim. It began in 1907 as a cable car capable of ferrying one mule at a time, and became a bridge in 1928. It is 440 feet long and was built at night to avoid the heat. The 550-foot-long cables of the suspension bridge couldn't be loaded on mules, and had to be carried down by teams of men.

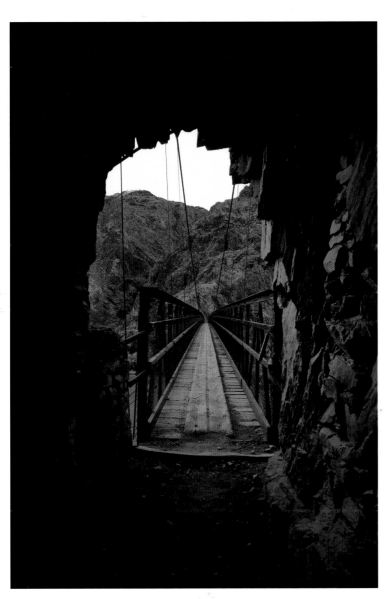

The Black Bridge tunnel.

Camping is available at the Bright Angel Creek campground with a reservation.

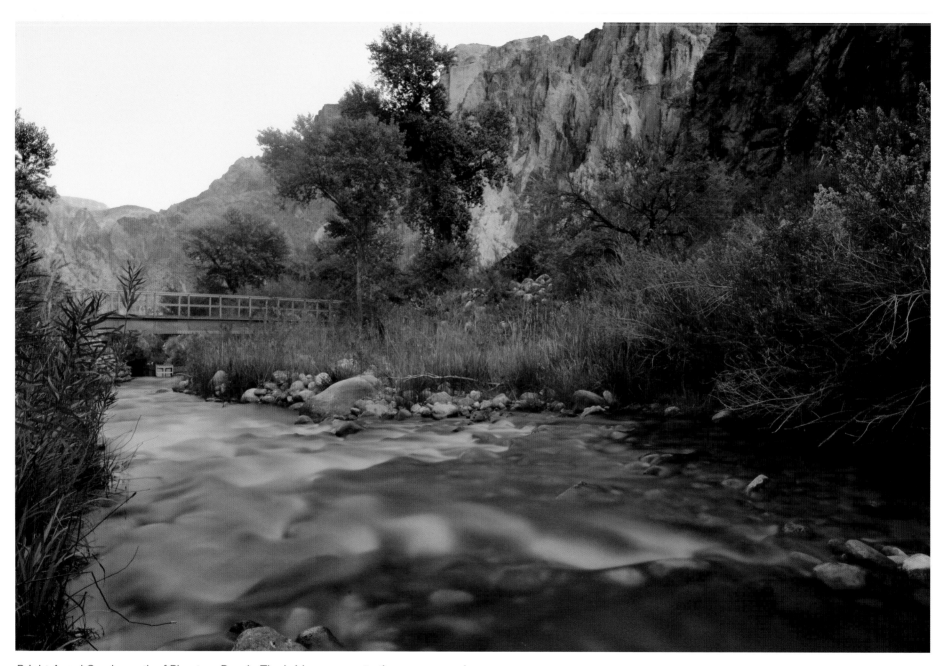

Bright Angel Creek, south of Phantom Ranch. The bridge crosses to the campground.

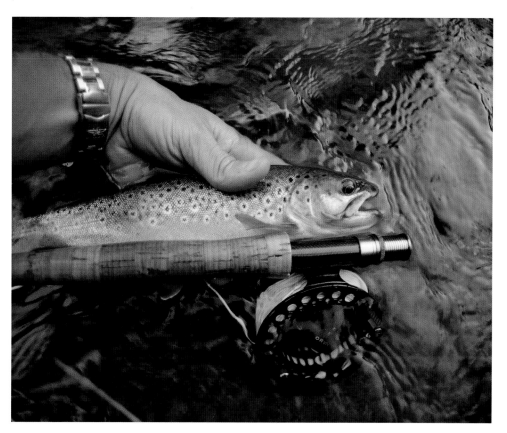

Brown trout caught in Bright Angel Creek. The river is a major spawning ground for brown trout, and is home to the endangered humpback chub.

Phantom Ranch, at the bottom of the Grand Canyon, near the confluence of Bright Angel Creek and the Colorado River, is reached only by foot or mule after descending 4,600 feet below the South Rim, or 5,800 feet below the North Rim. It was designed by Mary Colter in 1922 and is called National Park Service Rustic. Renamed Phantom Ranch by Colter after a nearby tributary to Bright Angel Creek, it was previously called Roosevelt Camp, after Theodore Roosevelt hunted here in 1913. Before then, it was called Rust's Camp, after David Rust, who developed the area and planted fruit and cottonwood trees for tourists in 1902.

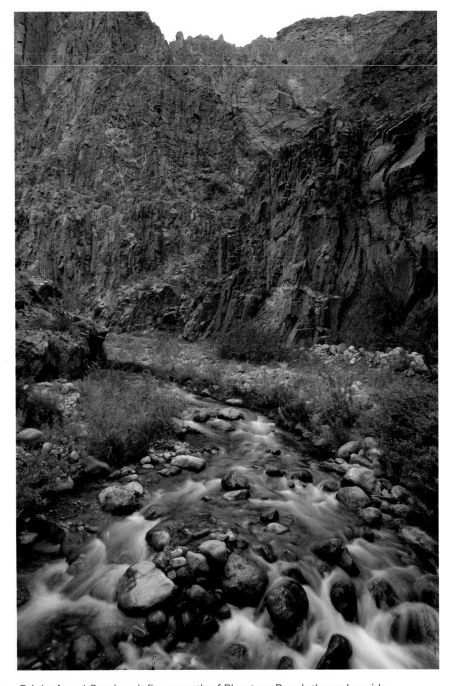

Bright Angel Creek as it flows north of Phantom Ranch through a side canyon called the Box.

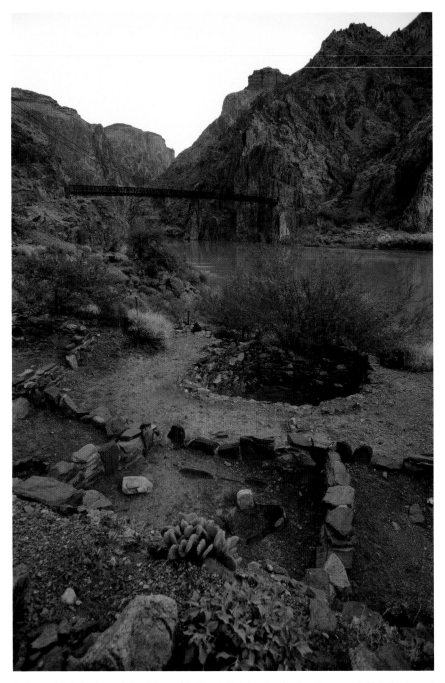

Ruins of Bright Angel Pueblo, with Black Bridge in the background. Bright Angel Pueblo was a small pueblo constructed in approximately A.D. 1050. It was excavated in 1969 by Douglas Schwartz of the School of American Research. It was first examined by John Wesley Powell during his exploration of the Grand Canyon in 1869. The ancient site shares ties to today's Hopi Pueblo of Arizona.

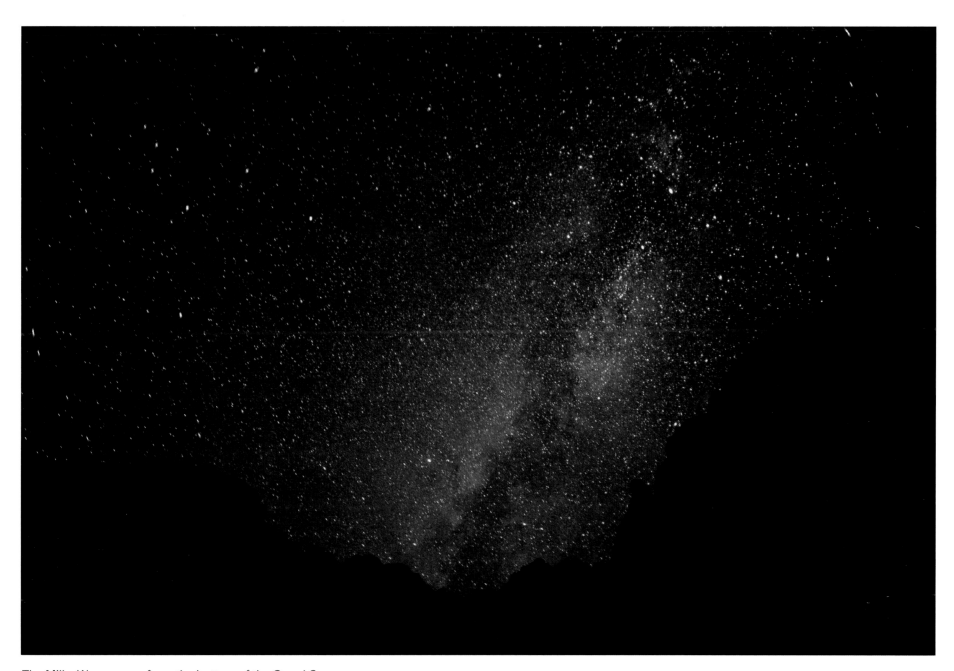

The Milky Way as seen from the bottom of the Grand Canyon.

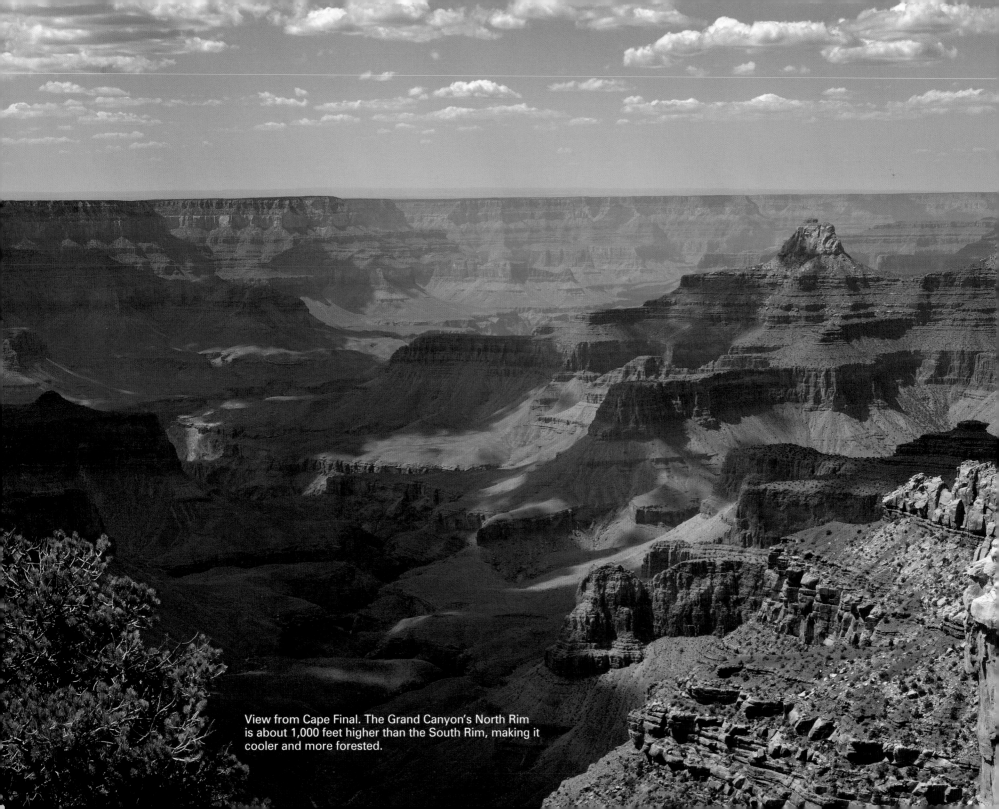

View from Cape Final. The Grand Canyon's North Rim is about 1,000 feet higher than the South Rim, making it cooler and more forested.

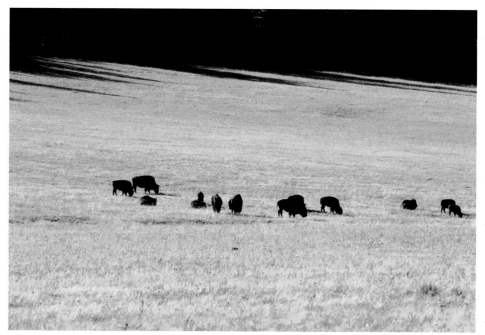

The bison herd near the entrance to the Grand Canyon's North Rim Visitor Center was introduced in the early 1900s to cross breed with cattle to produce "cattalo." The experiment failed; the bison were purchased by the Arizona Game and Fish Department in 1926. The herd is approximately 300 head and growing.

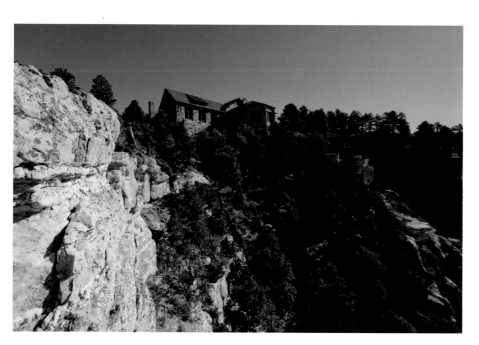

The North Rim Lodge was first constructed in 1928 by the Union Pacific System. It was built by the railroad to increase rail customers to Cedar City, Utah, who would then motor tour southern Utah and northern Arizona. The lodge burned in 1932, and the lodge here today was completed in 1937.

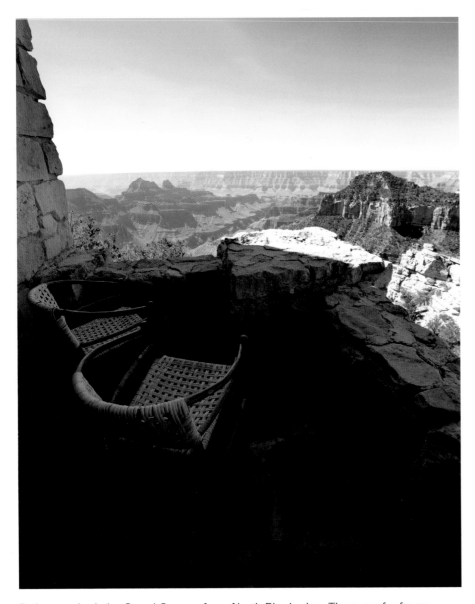

Patios overlook the Grand Canyon from North Rim Lodge. There are far fewer visitors to the North Rim than the South Rim, and some enjoy the thinner crowds and fewer facilities.

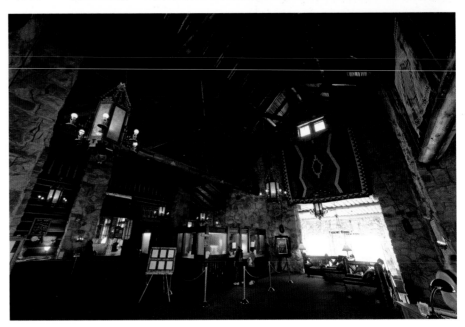

Lobby of the North Rim's Grand Canyon Lodge.

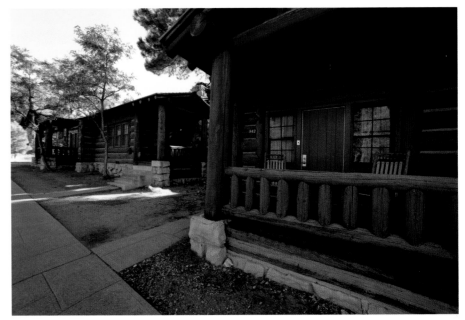

North Rim Lodge cabins.

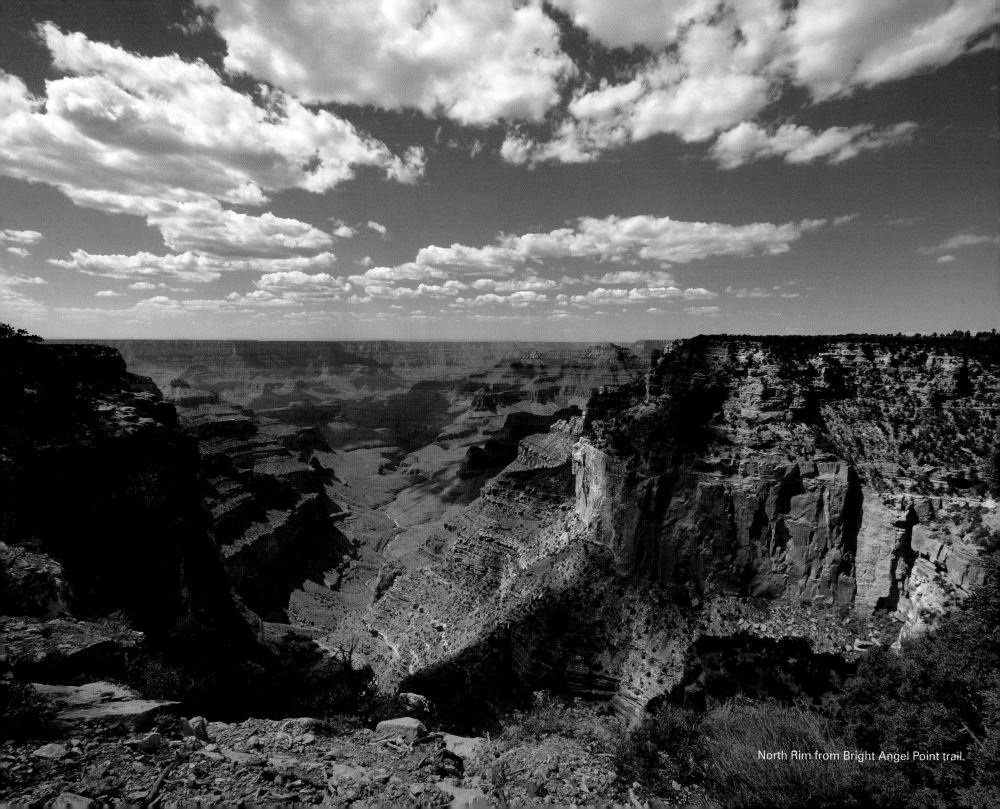

North Rim from Bright Angel Point trail.

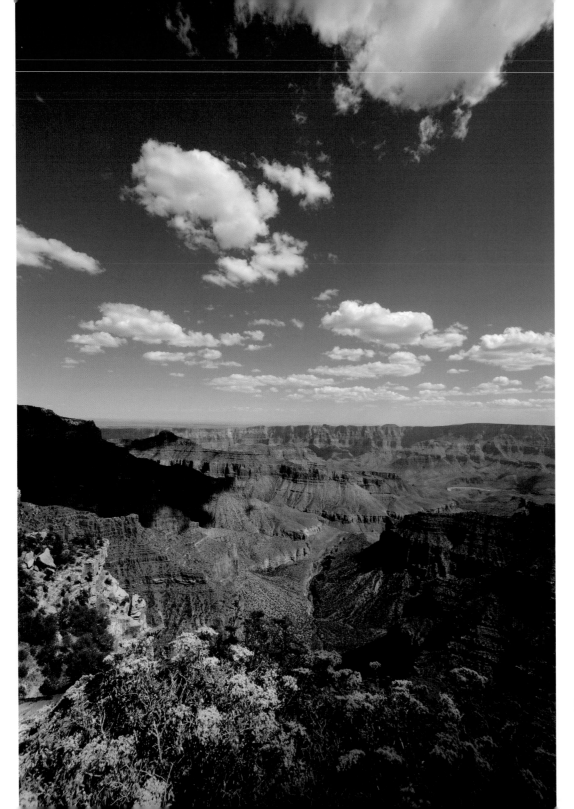

North Rim view from Cape Royal.

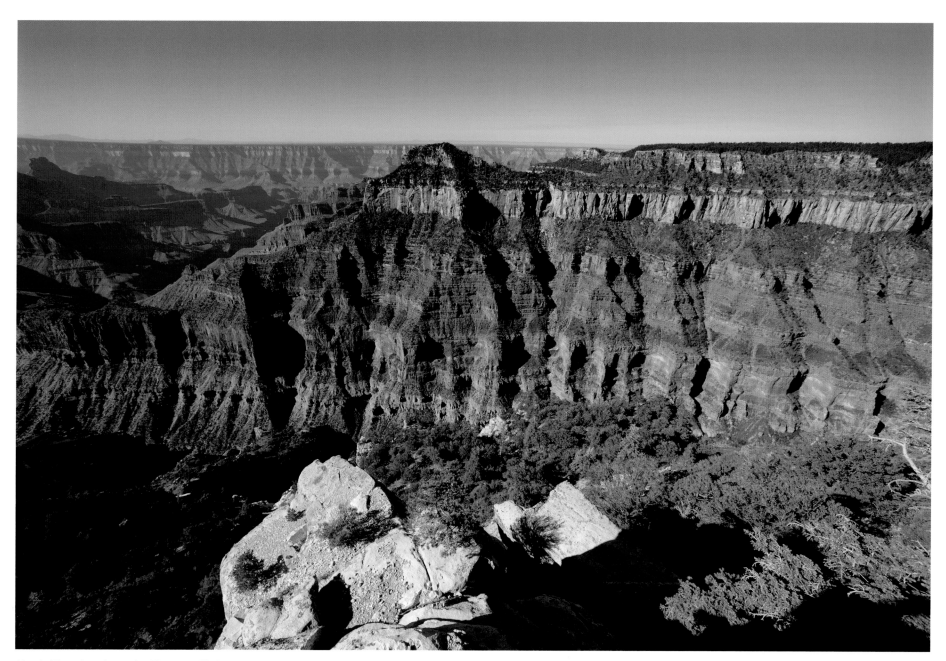

North Rim view from the Transept Trail.

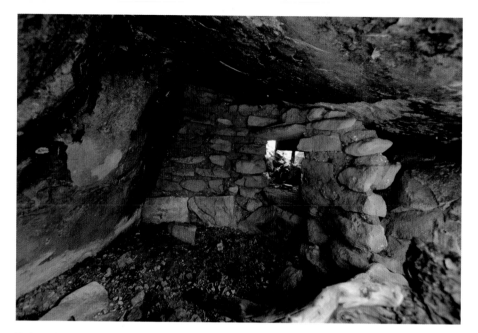

Ruins along Cliff Spring Trail.

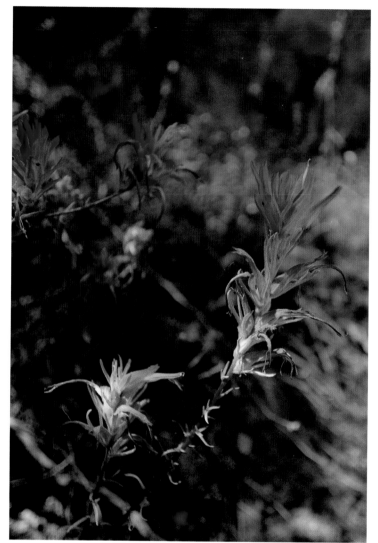

Indian Paint Brush.

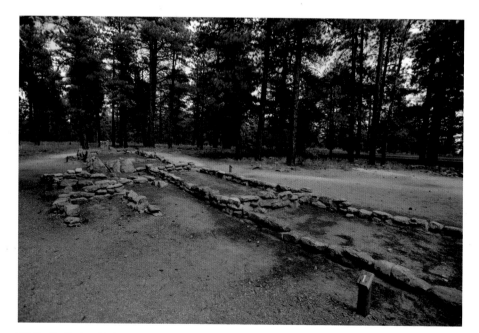

Walhalla Ruins lie just west of the Cape Royal Road in the Walhalla Glades. The small pueblo was built circa A.D. 1100, and has a clear line of sight to the Tusayán Pueblo across the canyon on the South Rim.

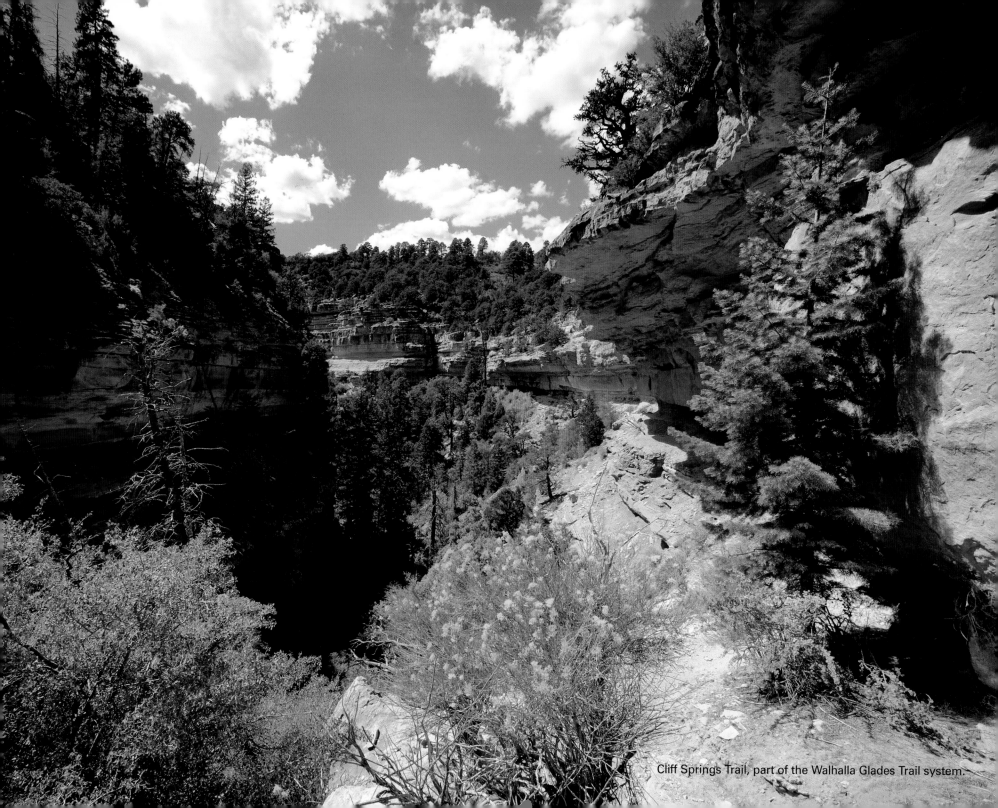

Cliff Springs Trail, part of the Walhalla Glades Trail system.

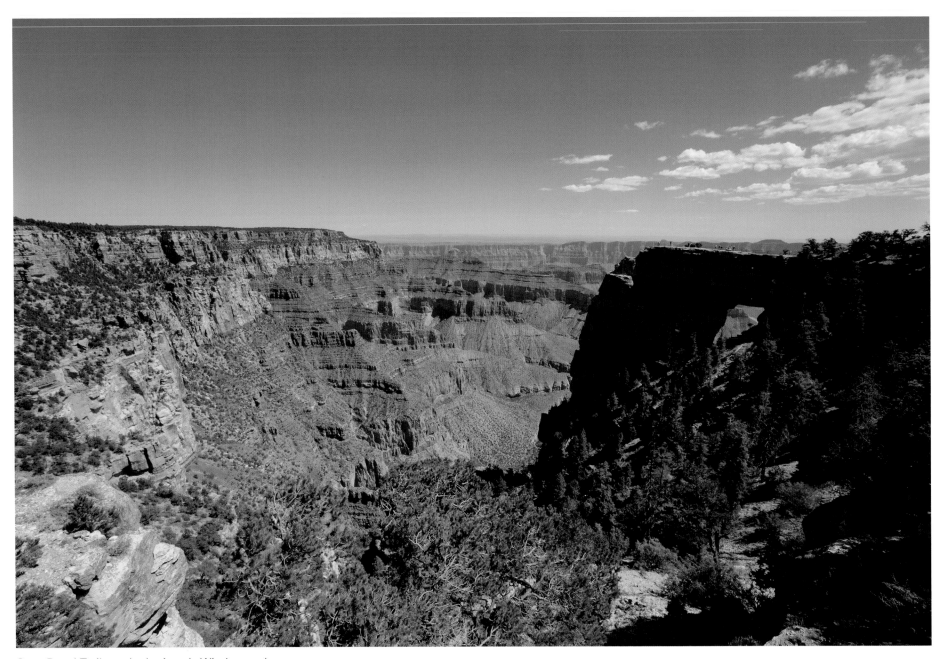

Cape Royal Trail overlooks Angels Window arch.

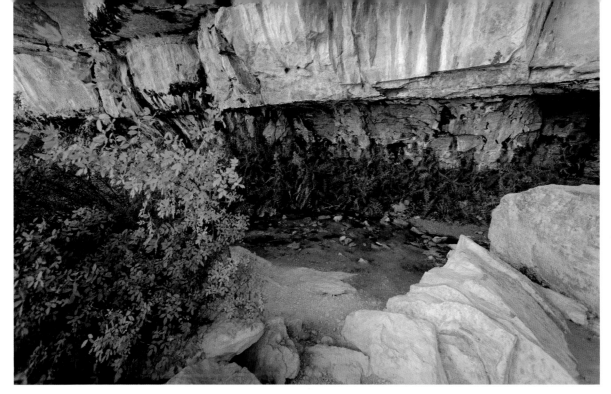

The springs for which Cliff Springs is named.

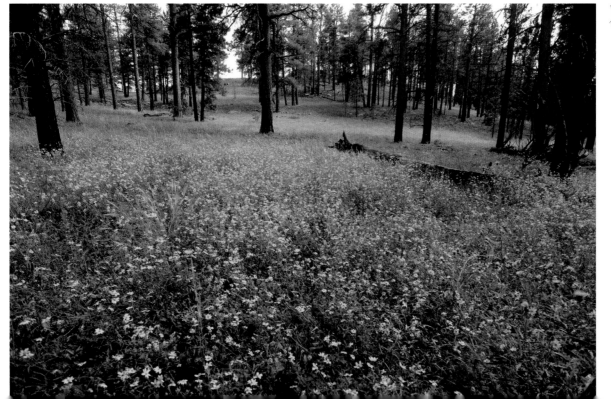

Wildflowers carpet the forest along the Cape Final Trail.

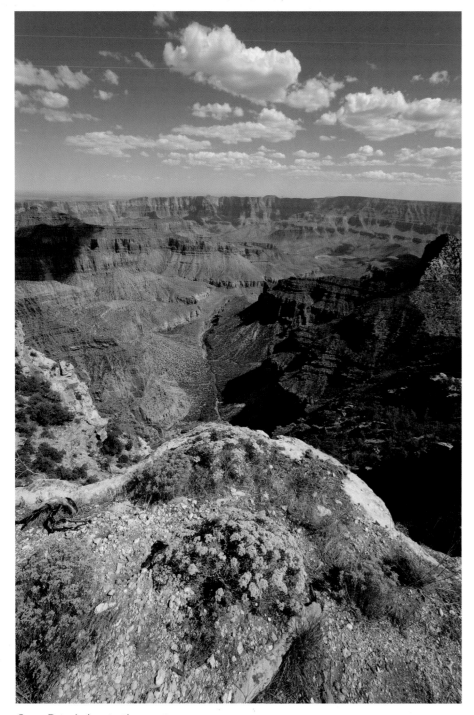

Cape Royal view to the west.

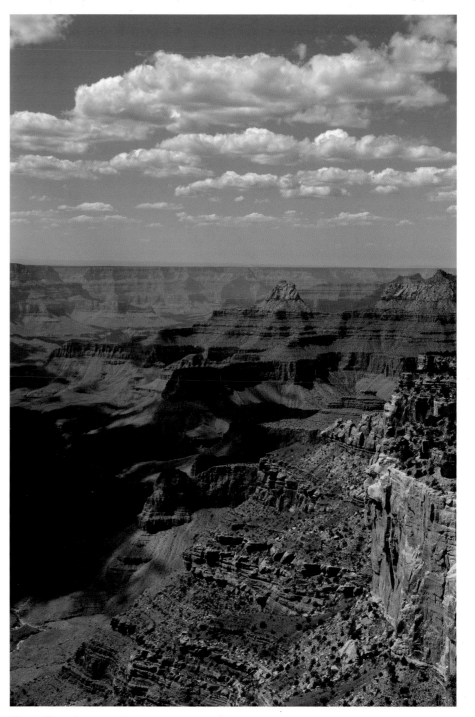

North Rim view near lodge.

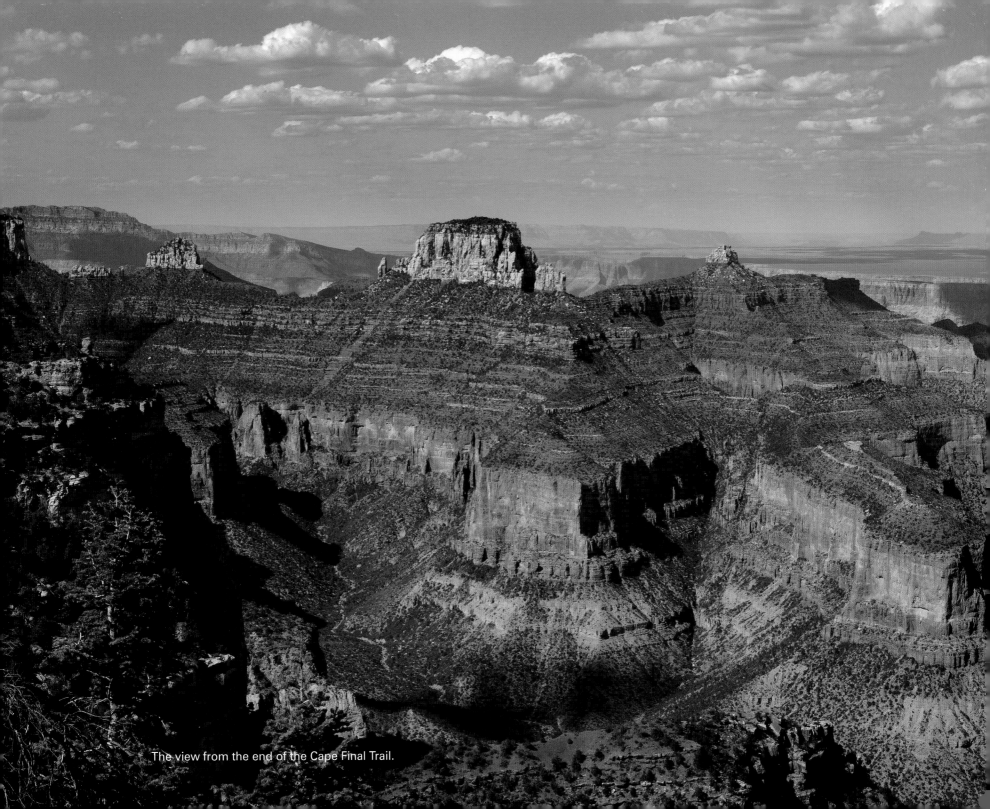
The view from the end of the Cape Final Trail.

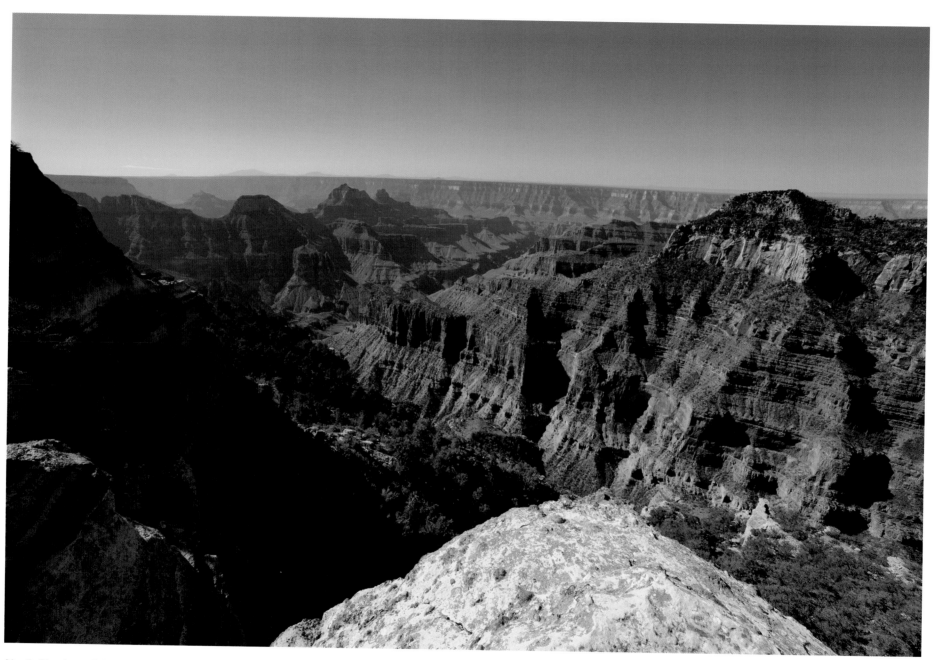

North Rim from Bright Angel Point.

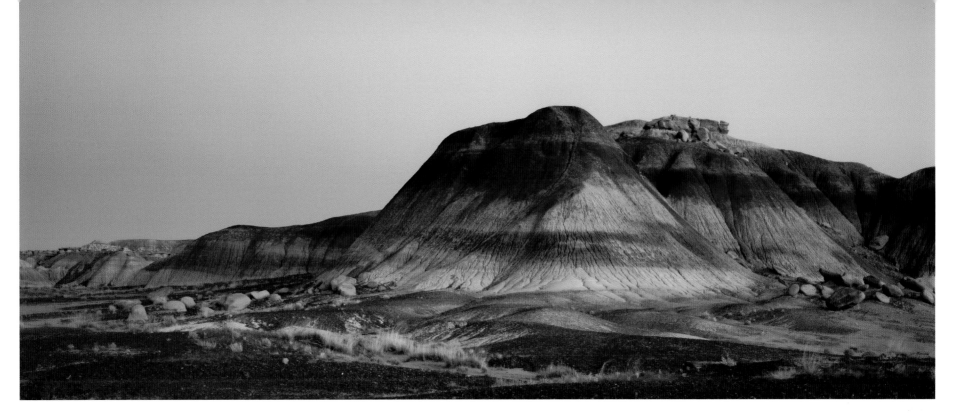

Battleship Rock in the Painted Desert, Arizona.

North Rim view from Roosevelt Point.

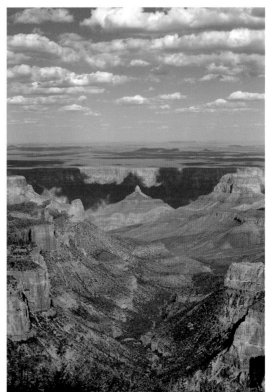

53

The Petrified Forest once had a climate similar to Panama today, during the Late Triassic Period. In addition to the thousands of petrified trees, fern and other tropical fossils are found here. Visit www.nps.gov/pefo for more information.

Petrified Forest National Park preserves 146 square miles of the largest concentration of petrified wood in North America.

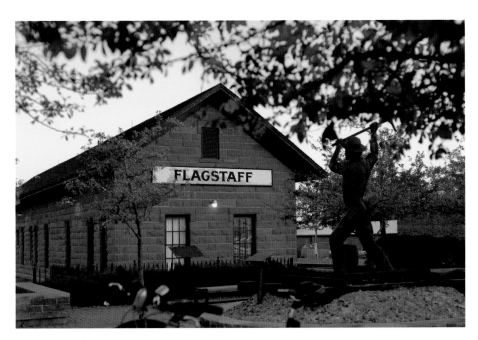

Flagstaff, Arizona, was founded in 1876 and is situated between the Grand Canyon and Sedona. It is named for a ponderosa pine flagpole erected here by Lt. Edward Beale in 1855 during a government surveying expedition. www.flagstaff.az.gov

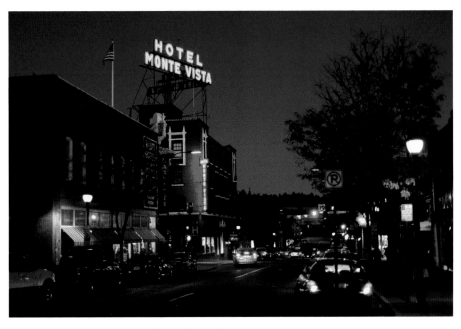

Route 66 was cut through Flagstaff in 1926, and the community became a city in 1928.

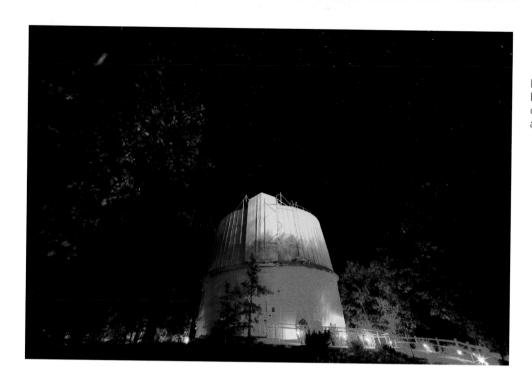

Lowell Observatory, where Clyde Tombaugh discovered Pluto in 1930, sits on Mars Hill overlooking Flagstaff. The observatory is responsible for many other notable discoveries, and is open to the public. www.lowell.edu

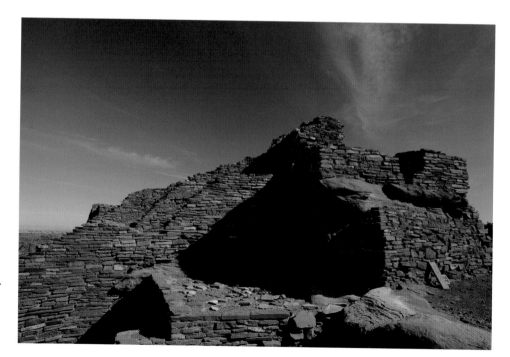

Wupatki Pueblo had 100 rooms and a ball court. Archaeologists believe that by A.D. 1182, 85 to 100 people lived here.

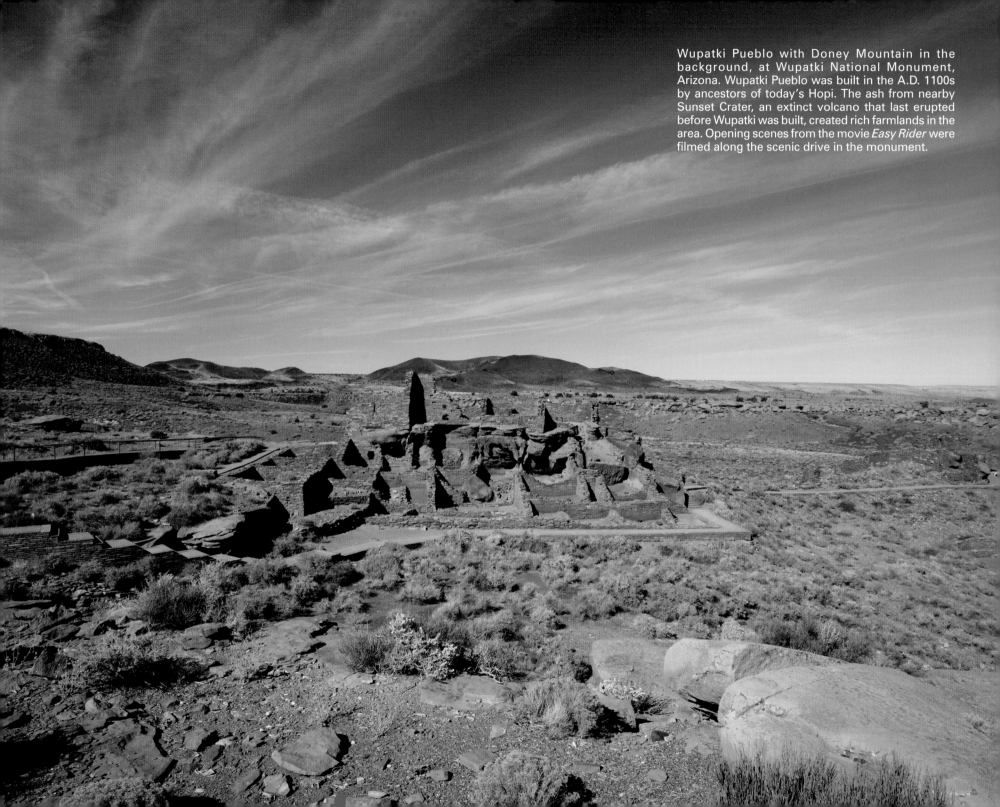

Wupatki Pueblo with Doney Mountain in the background, at Wupatki National Monument, Arizona. Wupatki Pueblo was built in the A.D. 1100s by ancestors of today's Hopi. The ash from nearby Sunset Crater, an extinct volcano that last erupted before Wupatki was built, created rich farmlands in the area. Opening scenes from the movie *Easy Rider* were filmed along the scenic drive in the monument.

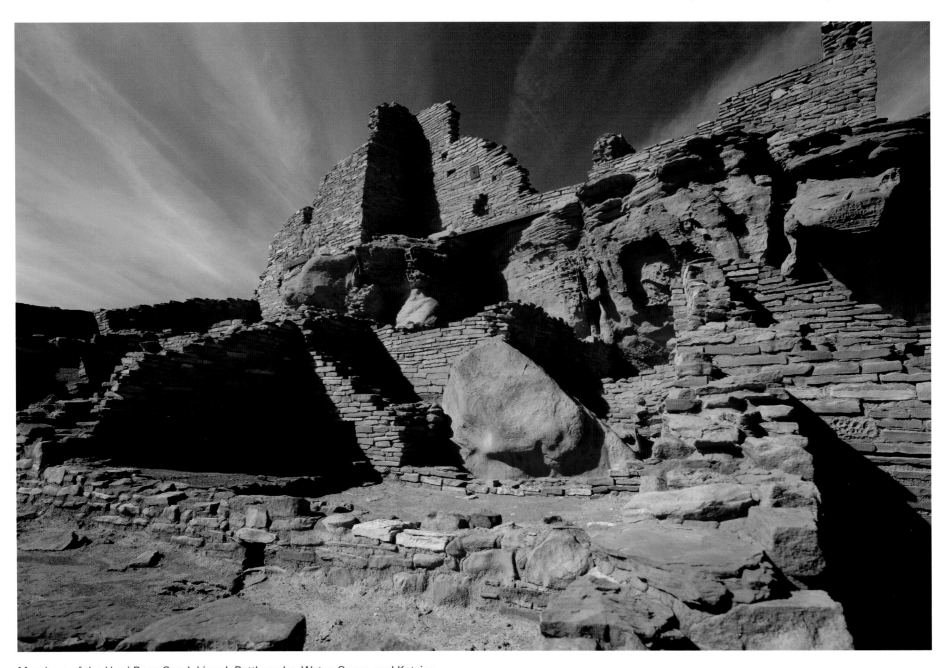

Members of the Hopi Bear, Sand, Lizard, Rattlesnake, Water, Snow, and Katsina clans still maintain a connection to Wupatki and periodically visit.

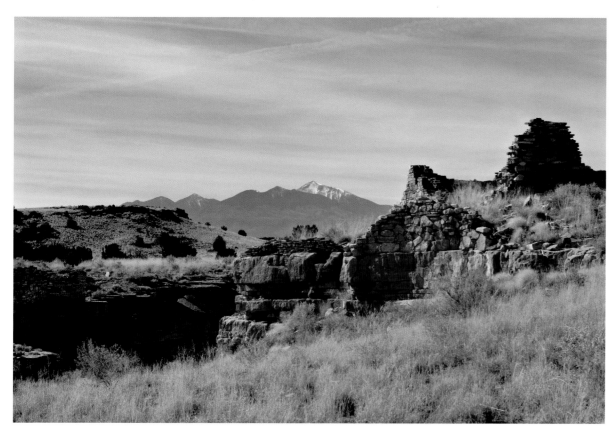

Box Canyon Ruins and the San Francisco Mountains at Wupatki National Monument. The San Francisco peaks are sacred to the Hopi, who traditionally believe their Katsinas live there.

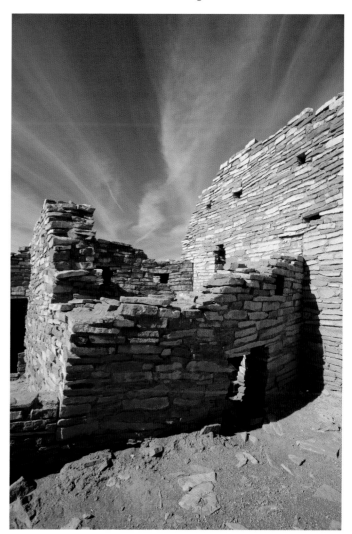

Citadel Pueblo, Wupatki National Monument. The national monument is 27 miles north of Flagstaff on US 89.

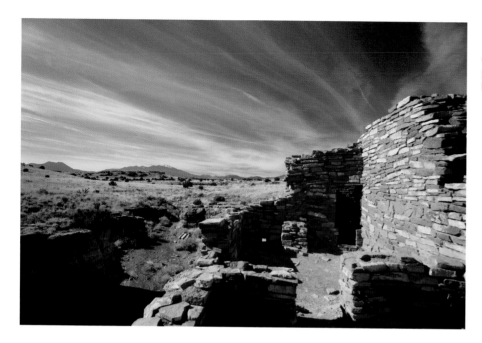

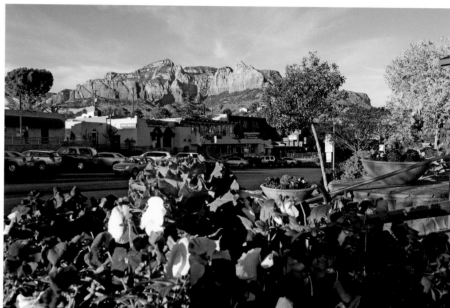

Citadel Pueblo. Six pueblo sites are open to the public within Wupatki National Monument that borders the Navajo Nation.

Uptown Sedona, south of Flagstaff, is known for its art galleries.

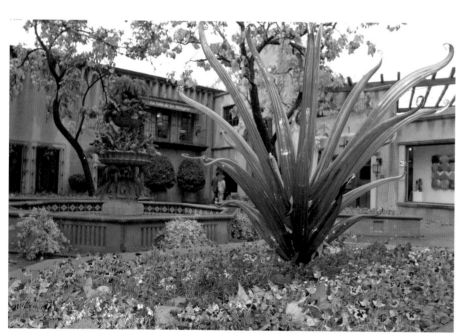

Sedona's Tlaquepaque shopping mall, Patio del Norte.

Interior of the Sedona Art Center.

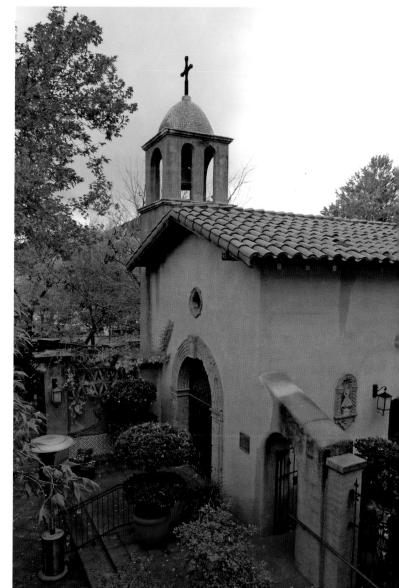

Chapel at Tlaquepaque.

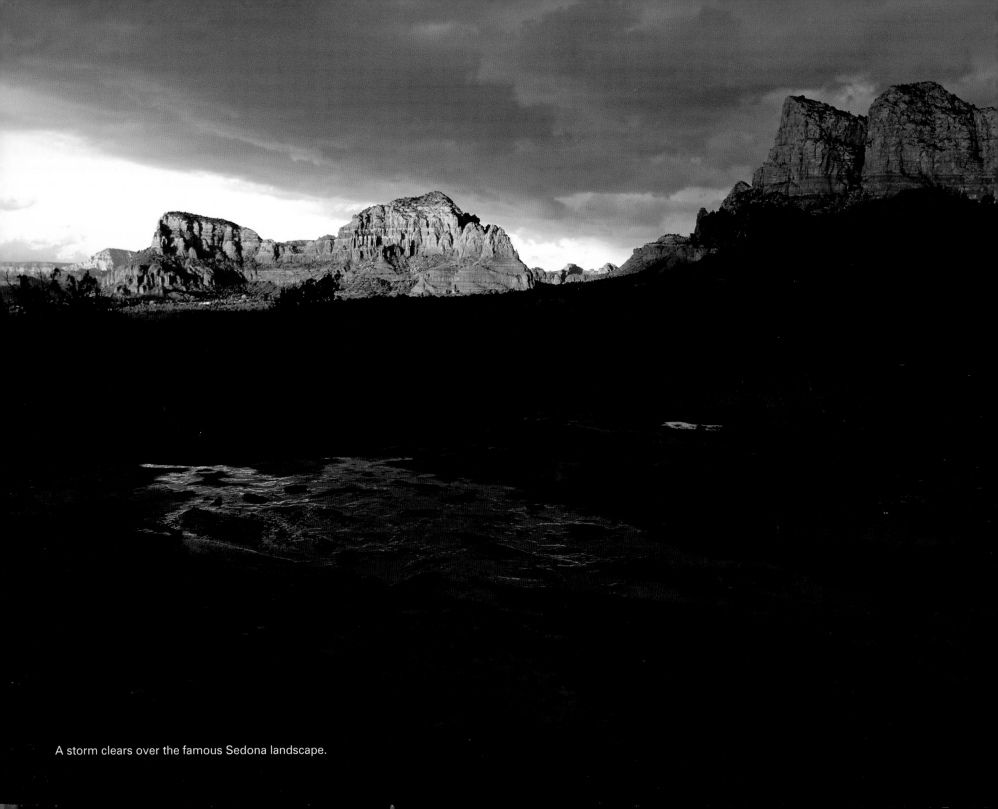

A storm clears over the famous Sedona landscape.

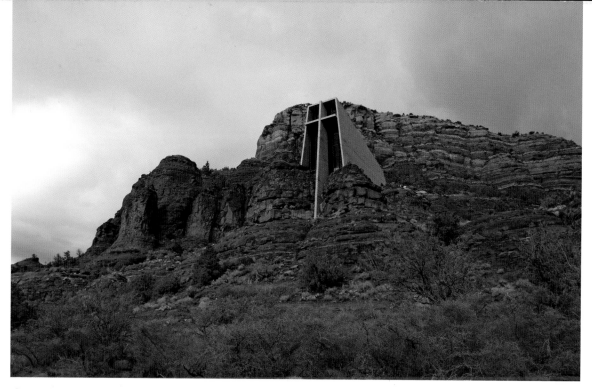

Chapel of the Holy Cross, Sedona. This Roman Catholic chapel was completed in 1956 and is a Sedona landmark.

Bell Rock and Courthouse Butte. Sedona is known for its vortices, or supposed areas of energy that draw New Age believers to areas, such as at Bell Rock, to draw energy and inspiration from the landscape.

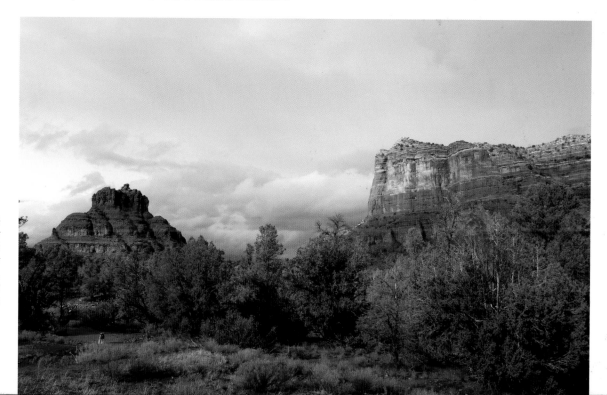

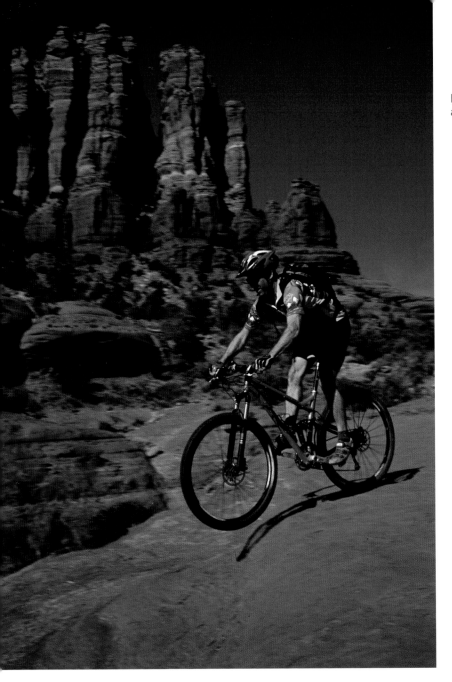

Mountain biking, hiking, and camping are all popular activities in Sedona's Coconino National Forest.

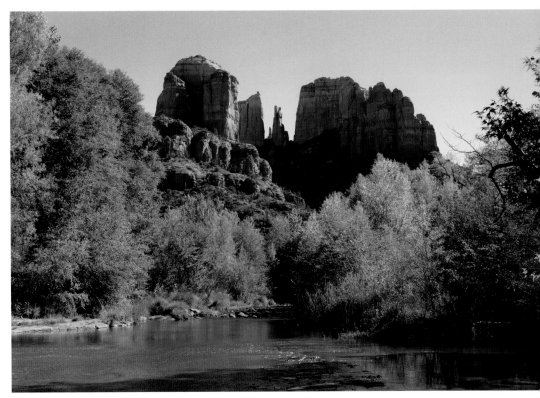

Oak Creek and Courthouse Butte and Red Rock Crossing in the fall.

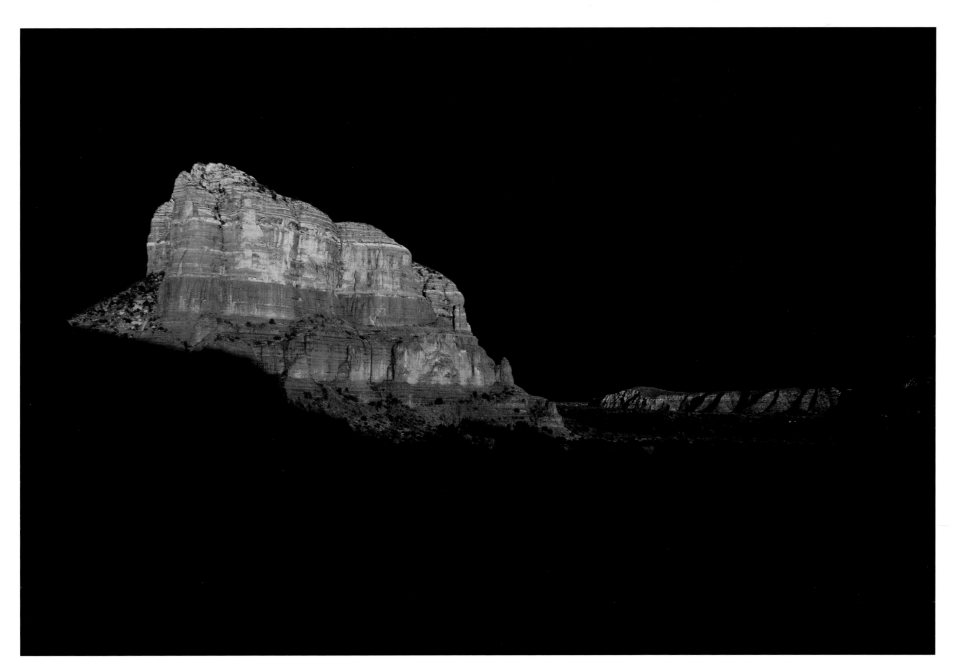

Sedona storm light. Sedona's red sandstone formations (from the same Supai
Group found in the Grand Canyon to the north) are famous for their glow.

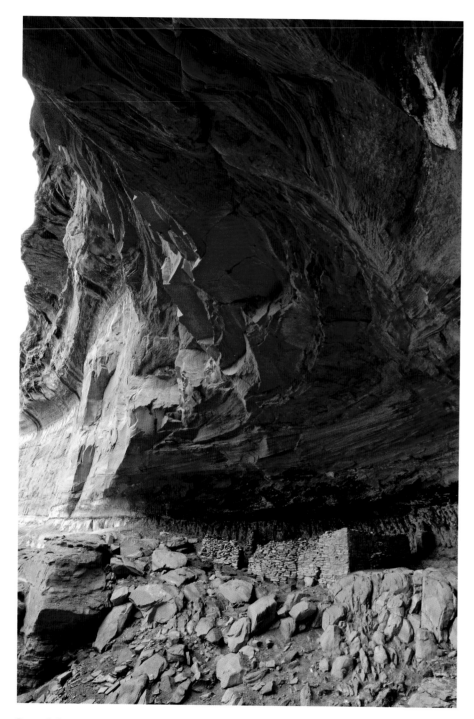

One of the many ancestral puebloan ruins found in the Sedona area.

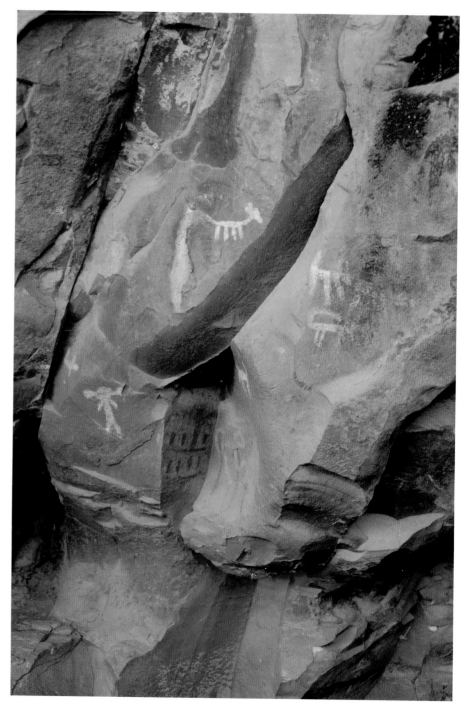

Petroglyphs at the Palatki Heritage Site near Sedona. The bun-hair of the petroglyph left-center is similar to the Hopi maiden-hair style still in use today.

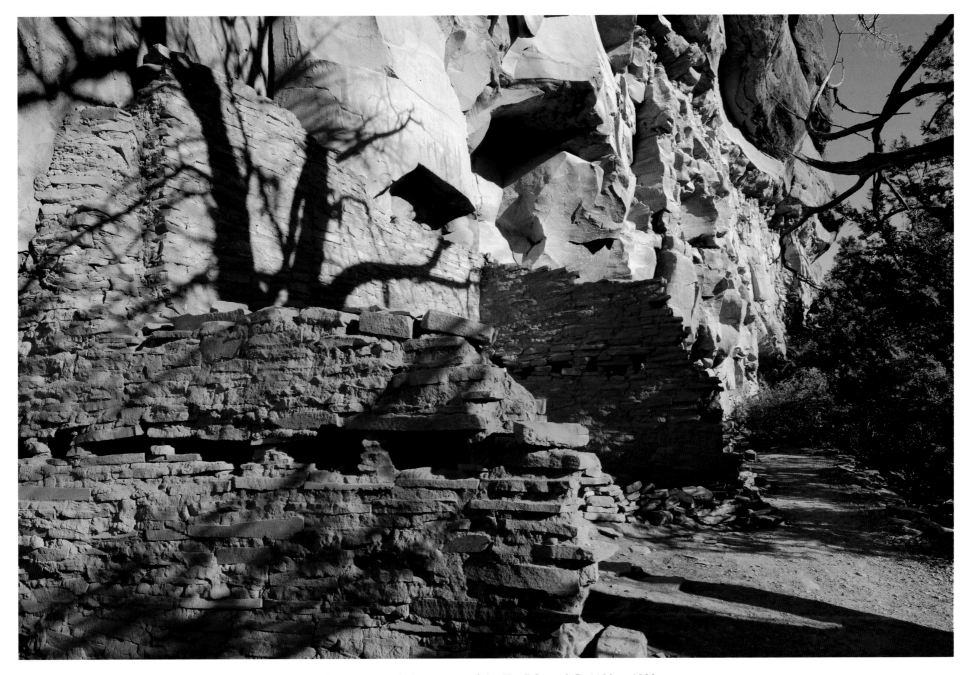

Honanki Heritage Site near Sedona was occupied by the Sinagua people (ancestors of the Hopi) from A.D. 1100 to 1300.

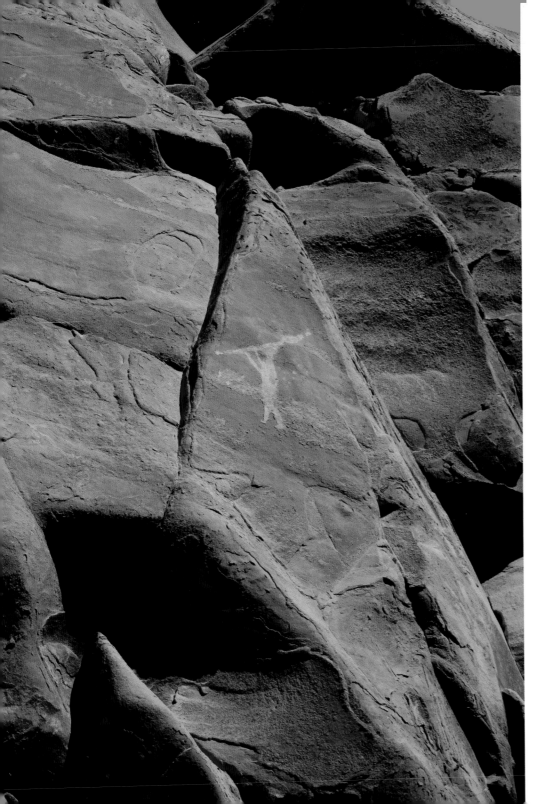

Cottonwood, Arizona: Founded in 1879, Cottonwood is located 19 miles southwest of Sedona on scenic 89A.

A classic kokopelli petroglyph at Honanki. This figure, used by many pueblos throughout the Southwest, is thought to represent fertility. The image has entered modern graphic art design representing the Southwest.

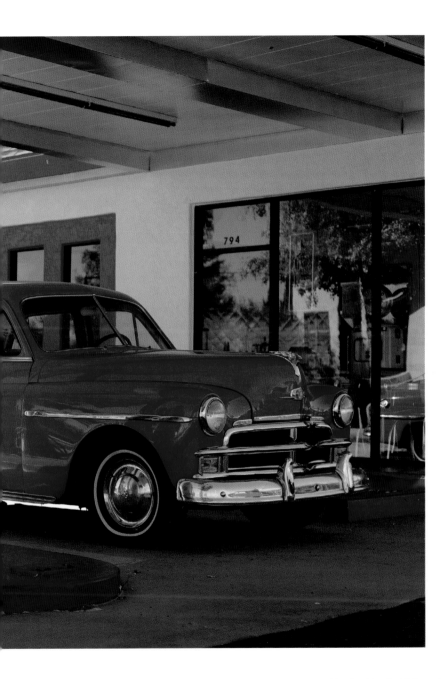

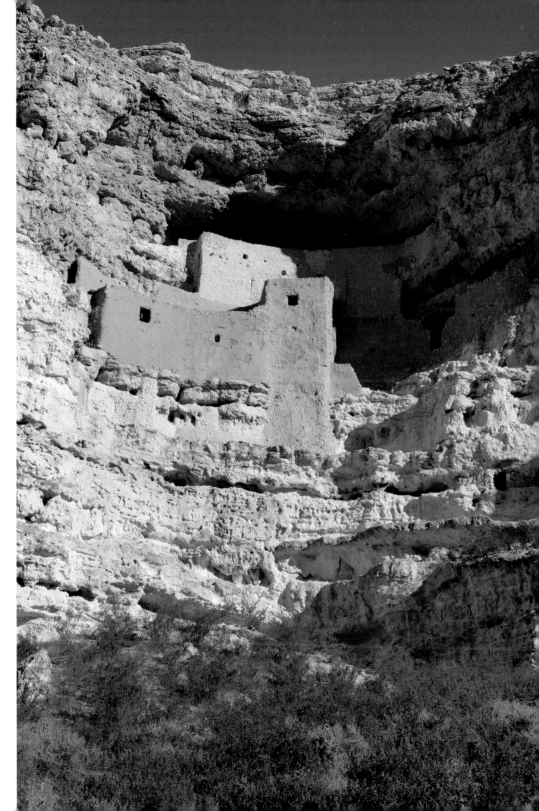

Montezuma Castle National Monument, Arizona. Located in the Verde Valley, this Sinagua (meaning "without water") cliff dwelling was incorrectly assumed to be part of the great Aztec Empire. In reality, this twenty-room dwelling was built in A.D. 1100 by the same ancestral puebloan people who occupied the Grand Canyon region and were ancestors of today's Hopi. www.nps.gov/moca.

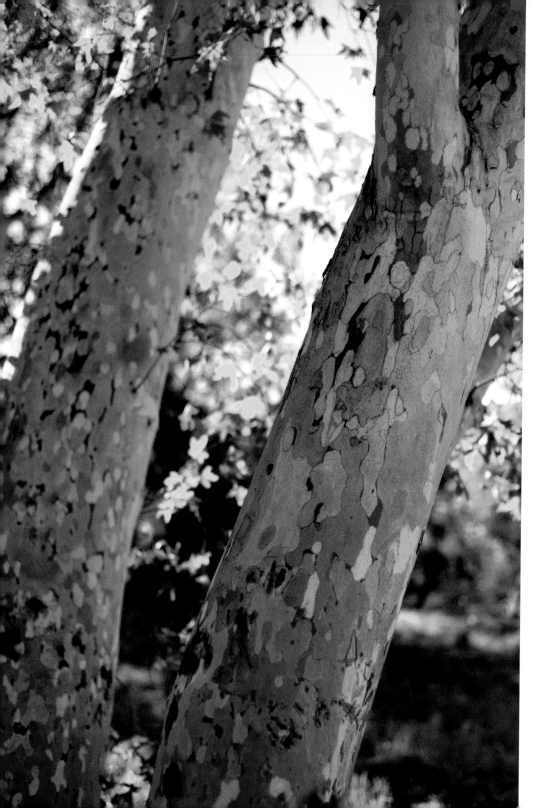

Arizona Sycamore tree: This white-barked tree was used extensively by the Sinagua as beams in their structures.

Tuzigoot National Monument, Arizona. This Sinagua pueblo near Cottonwood sits on a hill overlooking the Verde Valley.

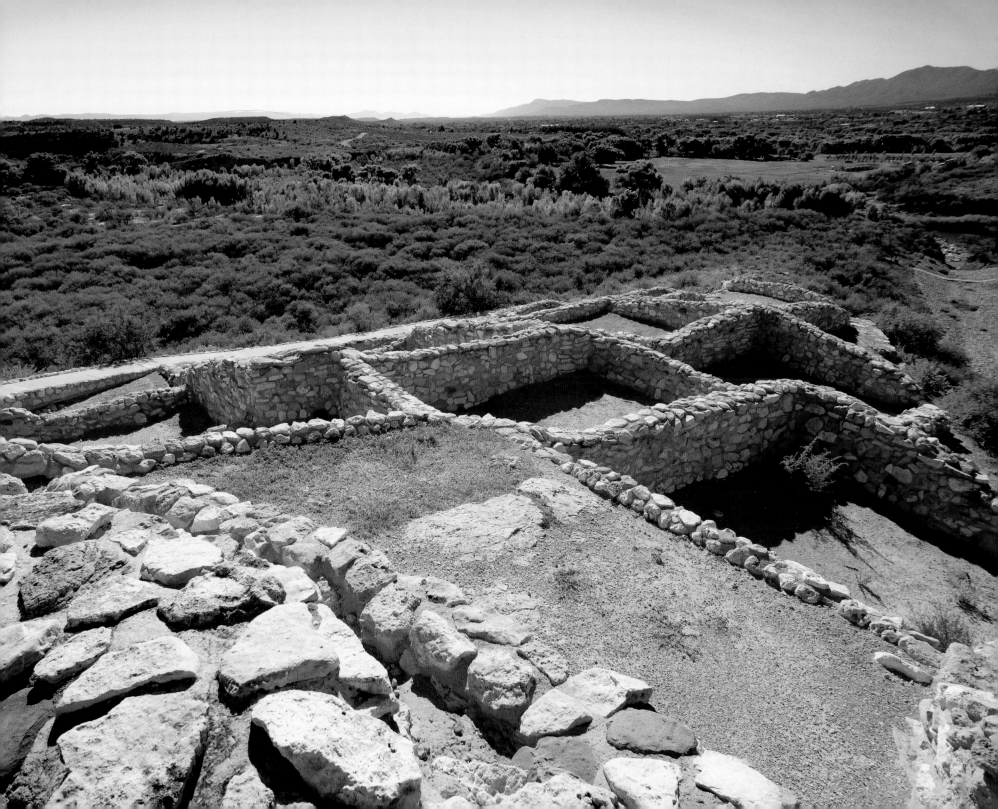

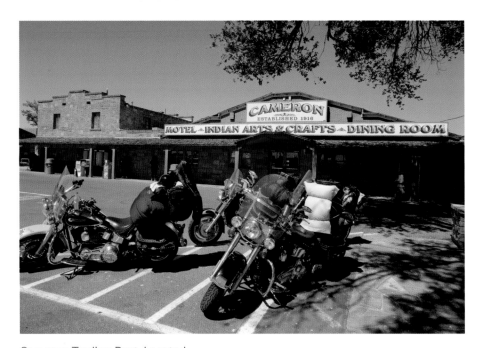

Cameron Trading Post interior.

Cameron Trading Post. Located thirty minutes from the Grand Canyon's East Entrance on AZ 64, this trading post/restaurant/hotel was built in 1916 to take advantage of the growing tourist traffic to the Grand Canyon. Today it is a major supporter of Hopi and other Native American arts.

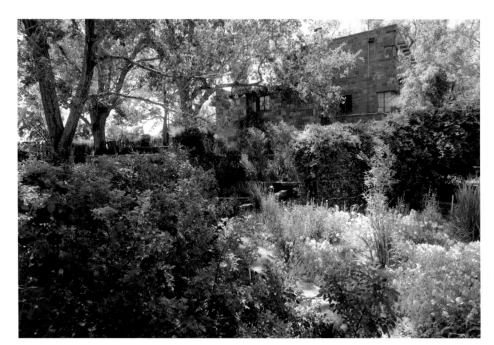

Cameron Trading Post gardens.

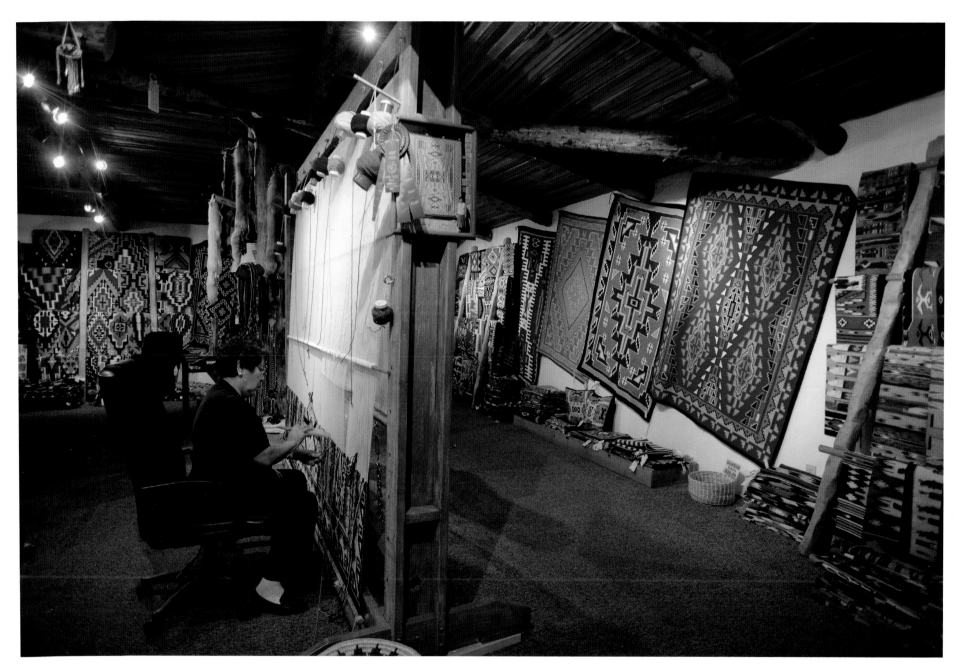

Navajo master weavers demonstrate their talent in the Cameron Trading Post weaving room.

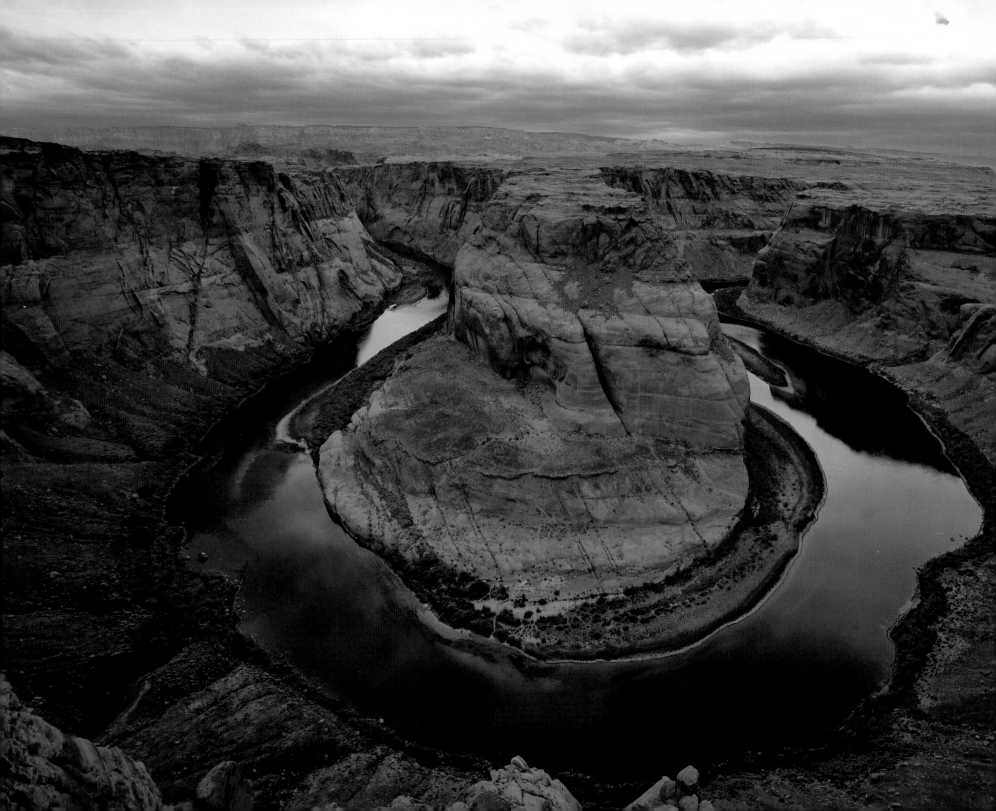

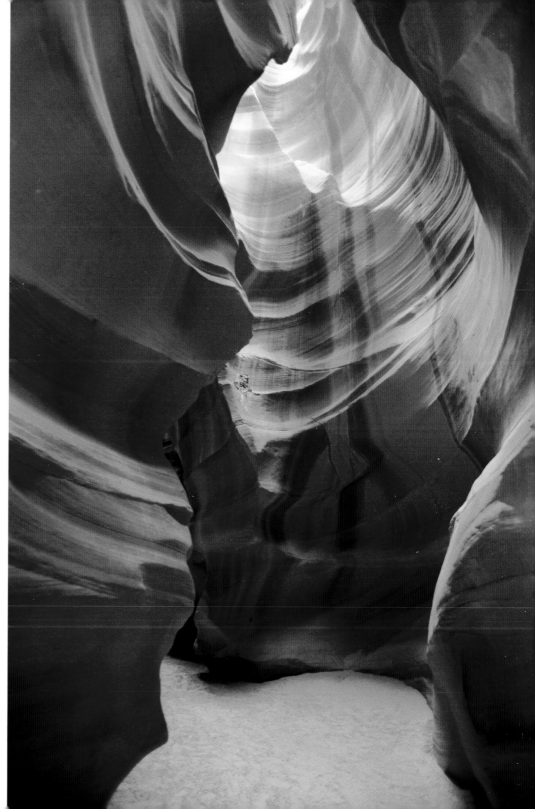

Antelope Canyon, Arizona, near Page. This slot canyon, managed by the Navajo Nation, is a favorite of photographers worldwide (right and following two pages).

Horseshoe Bend, Colorado River, south of Page, Arizona.

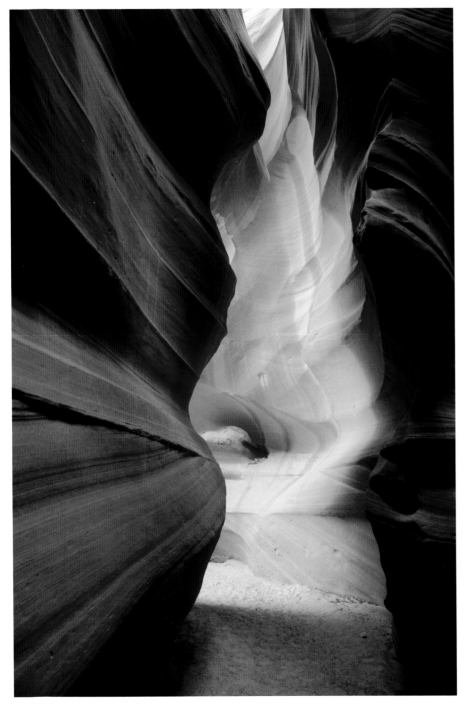
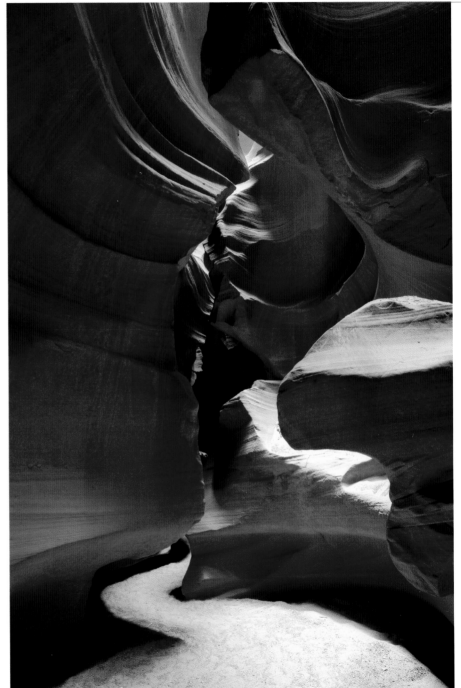

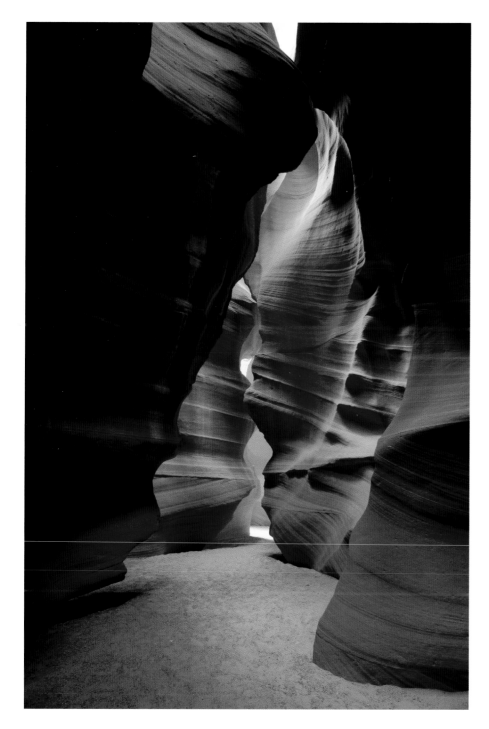
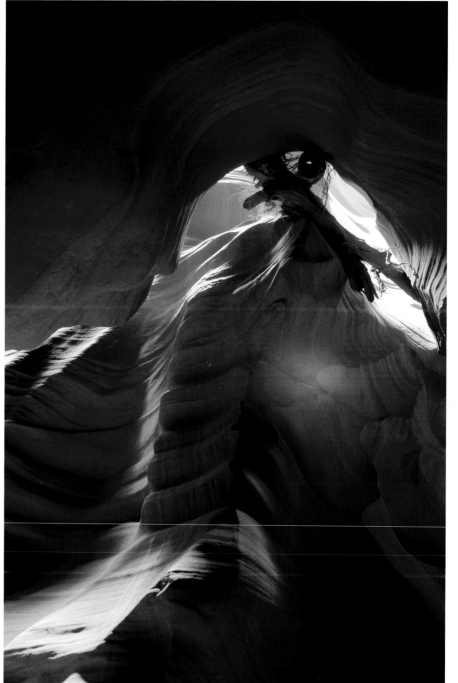

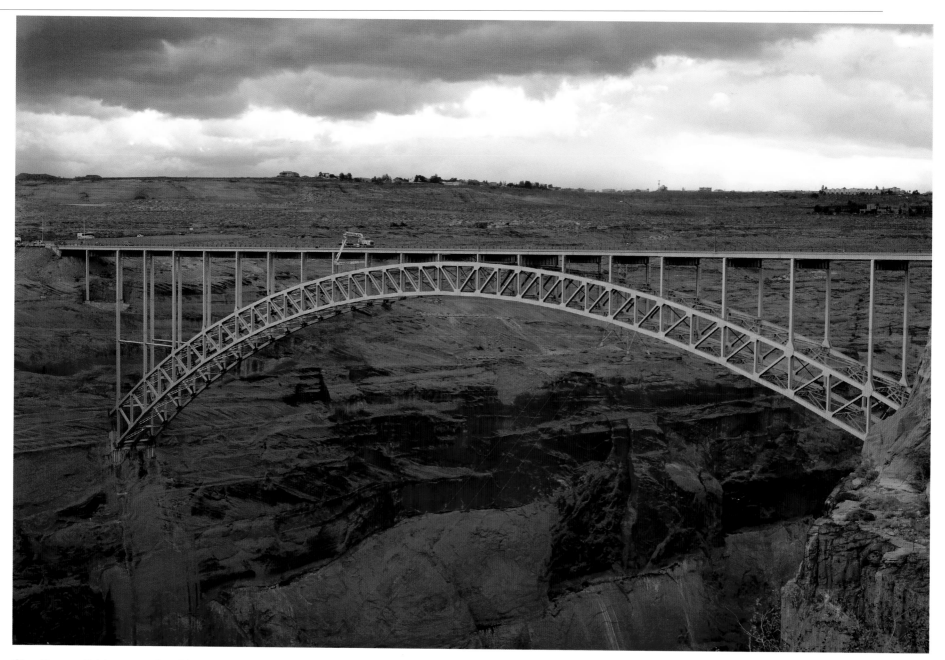

Glen Canyon Bridge, completed in 1959, carries US 89A across the Colorado River 690-feet above the river near Page.

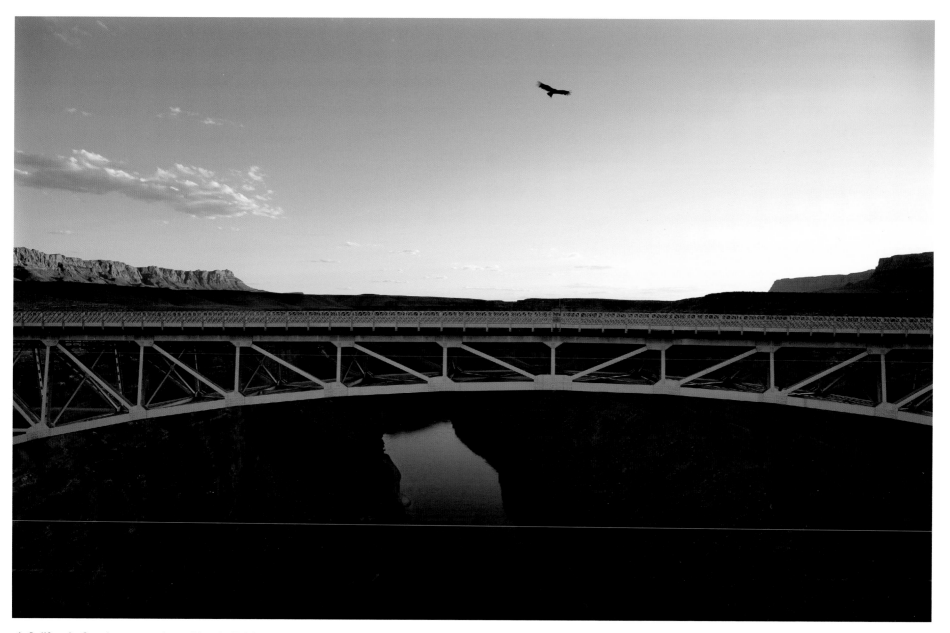

A California Condor soars above Navajo Bridge, which spans the Colorado River and affords breathtaking views of Marble Canyon north of the Grand Canyon. The California Condor numbered only twenty-two birds in 1987, but thanks to conservation efforts, numbered almost 400 birds in 2011, 181 of which live in the wild. North America's largest land bird, the California Condor is only found in the Grand Canyon area and can live to 60 years.

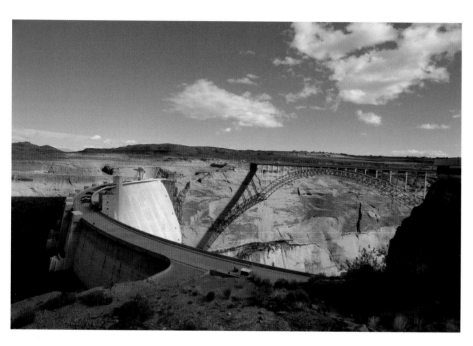

Glen Canyon Dam, near Page, was completed in 1966 and created Lake Powell on the Colorado River. The Glen Canyon Dam Bridge carries US 89 into Utah. The dam produces electricity for nearby communities, and its water releases affect Colorado River levels within the Grand Canyon.

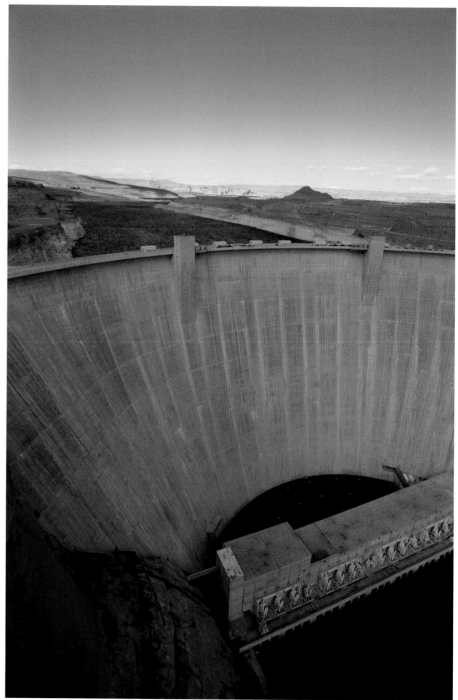

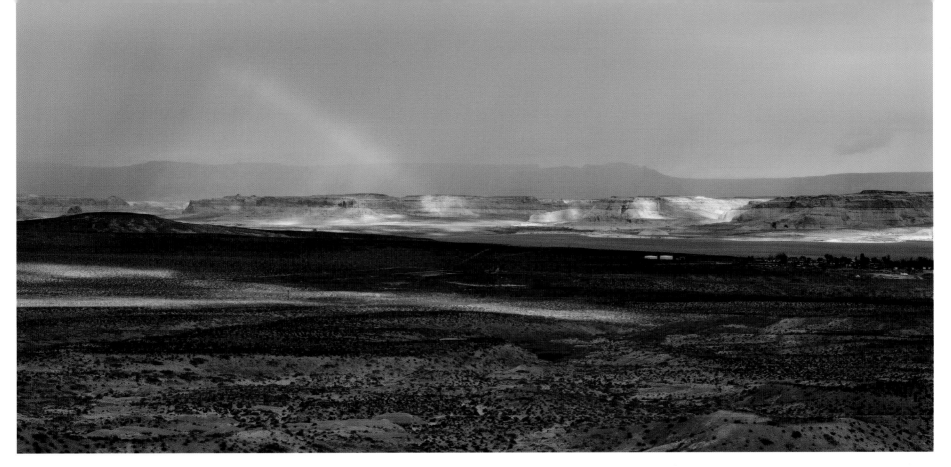

Rainbow over Lake Powell. Lake Powell is the second largest manmade reservoir in the United States, after Lake Mead in Nevada.

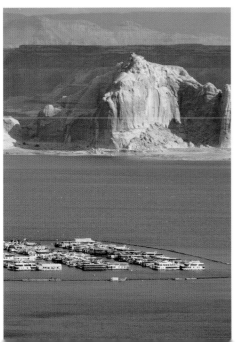

Lake Powell allows boating and water sport activities in the middle of an otherwise desert environment. Houseboating is a popular activity.

Sunset over the Paria Canyon-Vermilion Cliffs Wilderness on the Utah/Arizona border, north of the Grand Canyon.

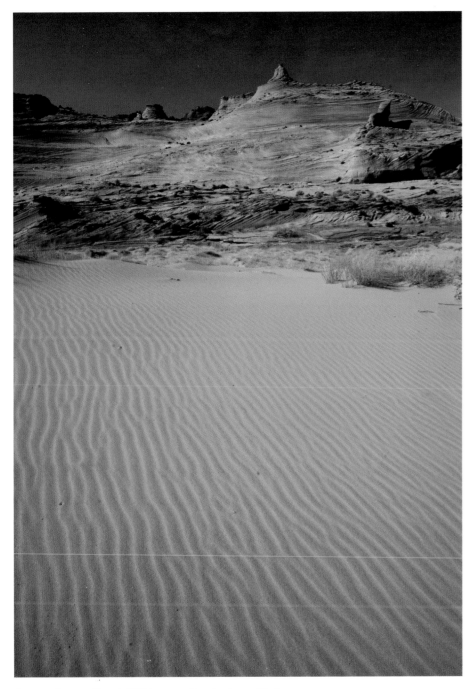

Coyote Buttes South Wilderness Study Area, Utah.

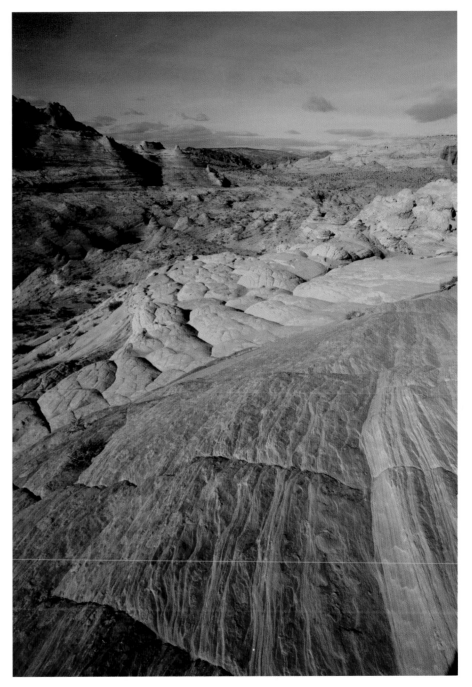

Coyote Buttes is a Special Management Area of the Paria Canyon-Vermilion Cliffs Wilderness area on the Utah/Arizona border. It is known for its surreal Navajo Sandstone formations.

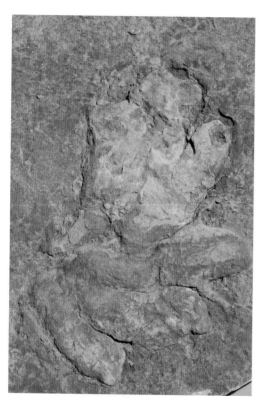

Dinosaur tracks are commonly found in the Jurassic Period rock in the Coyote Buttes area.

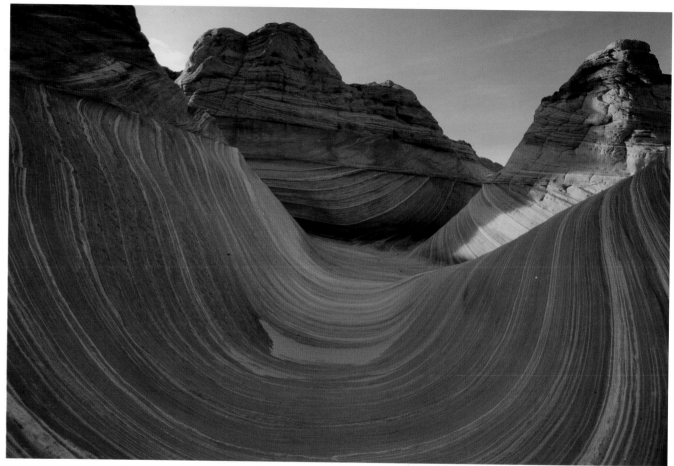

The Wave, a windswept formation of Jurassic sandstone in the Coyote Buttes South Wilderness Study Area, is a permit-only destination reached after a three-mile hike through a psychedelic landscape.

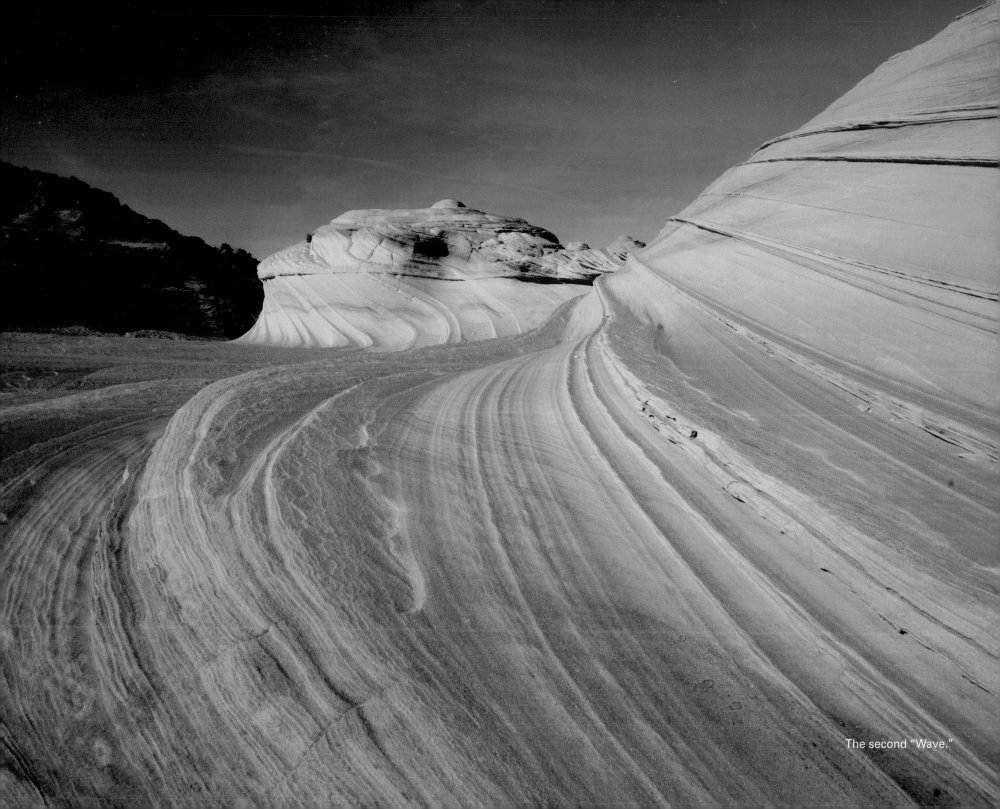

The second "Wave."

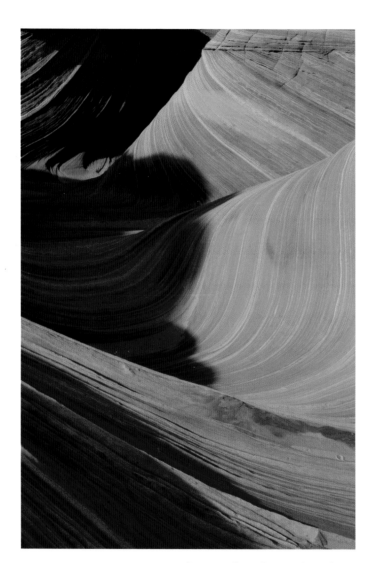

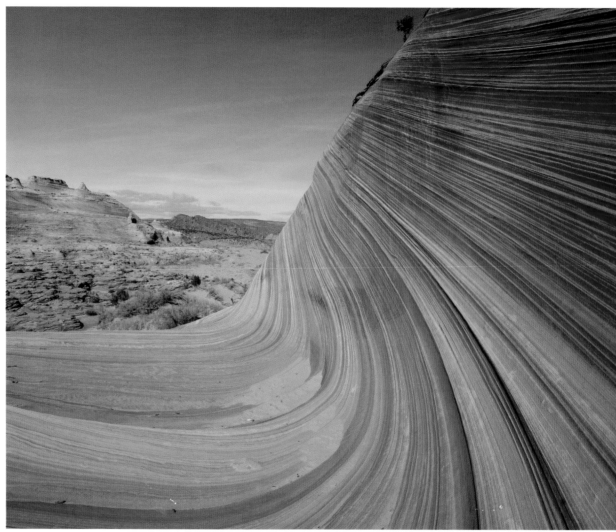

Layers of sandstone deposited over millennia, then exposed by wind, create the unique strata. (Above and opposite page.)

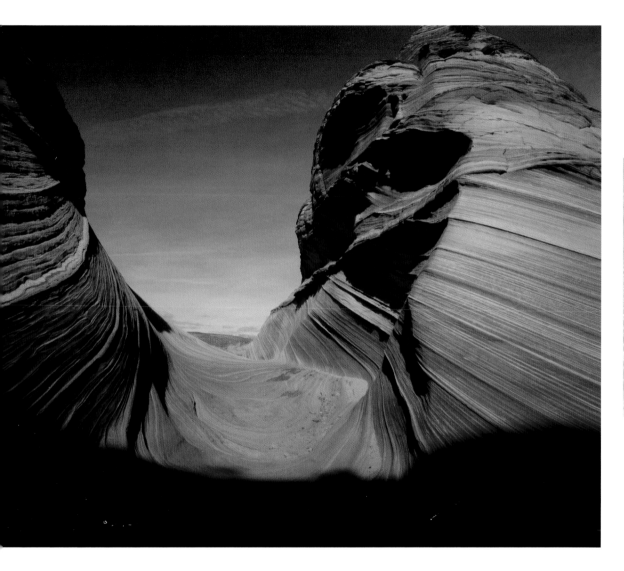

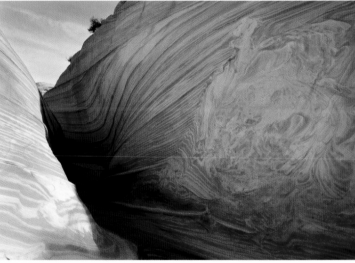

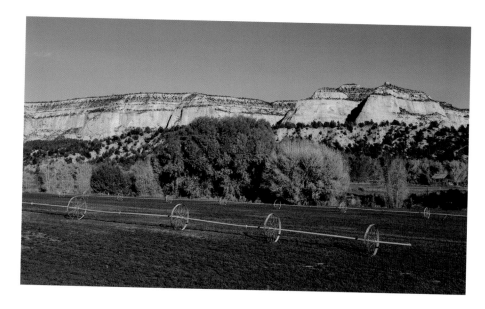

Irrigation makes farming possible in the desert terrain of southern Utah, as seen along US 89 in Utah. The area was settled by Mormon farmers in the 1800s.

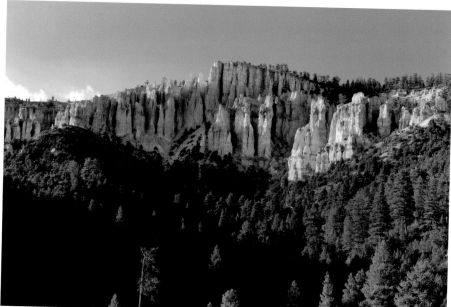

Bryce Canyon National Park, Utah, is a spectacular landscape of sandstone spires, called hoodoos, formed through freeze/thaw erosion in a bowl setting. The National Park was established in 1928.

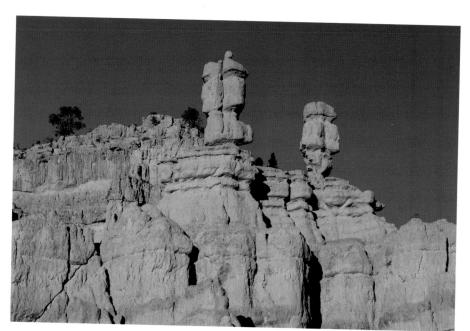

Bryce Canyon hoodoos.

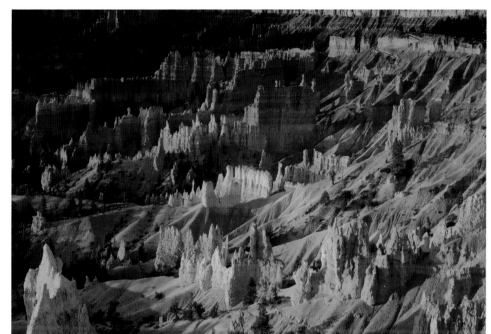

Sunrise Point, Bryce Canyon National Park.

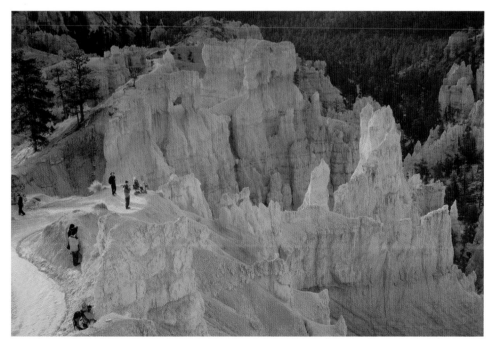

Early morning hikers at Bryce Canyon.

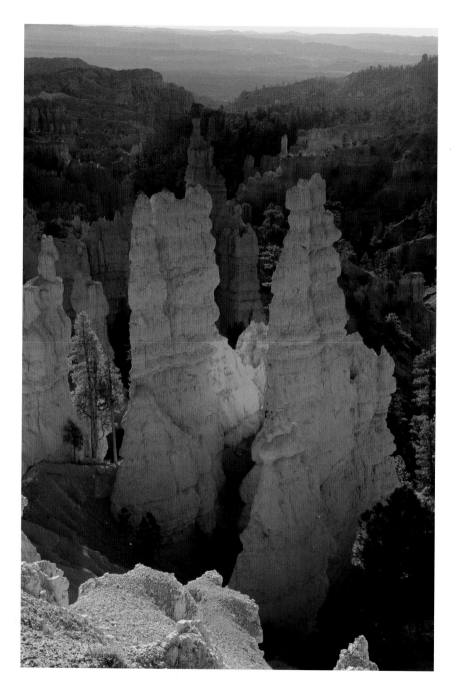

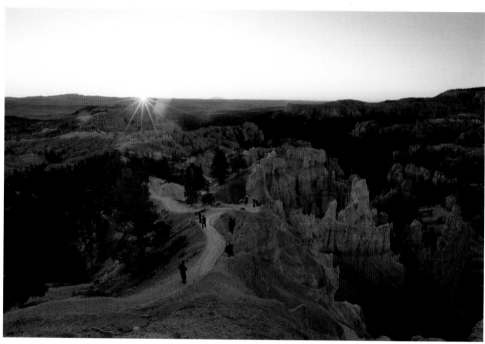

Bryce Canyon. (left, above, and opposite page)

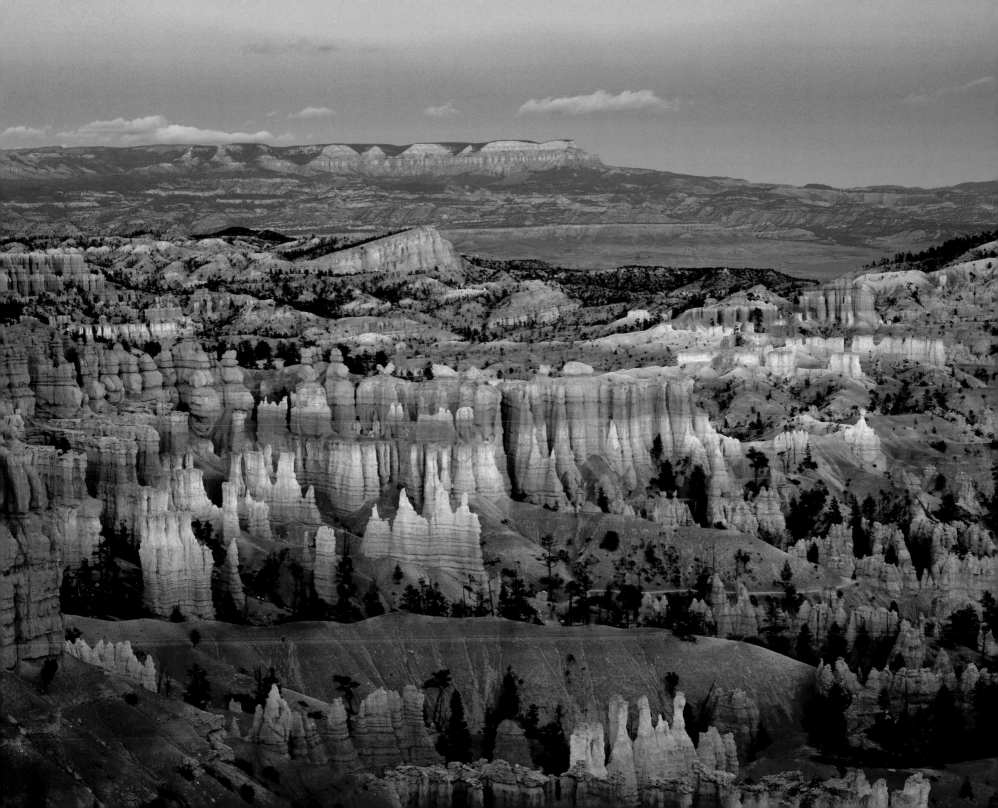

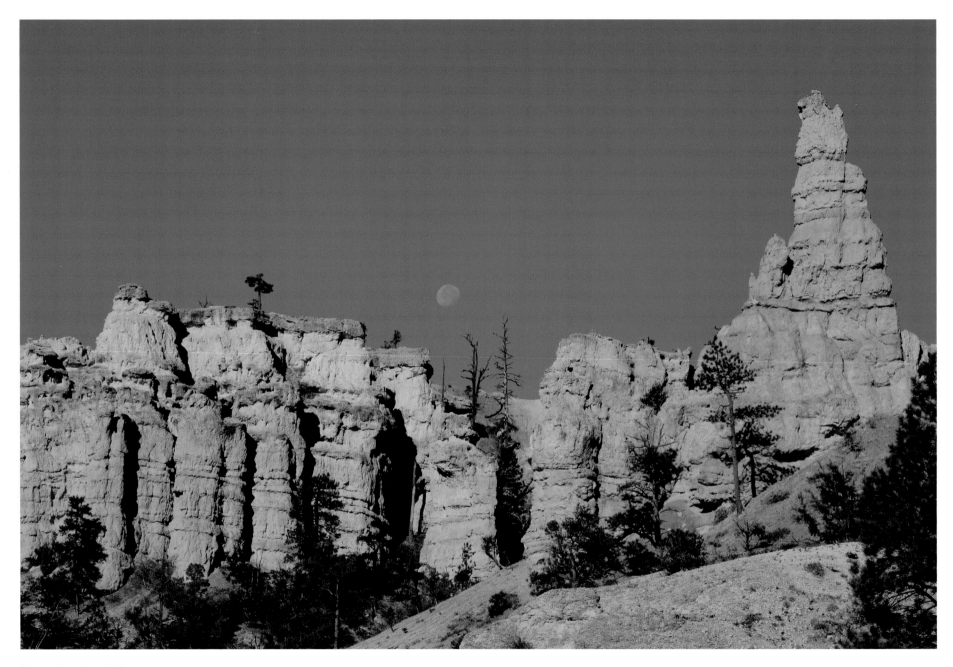

Moonrise along UT 12.

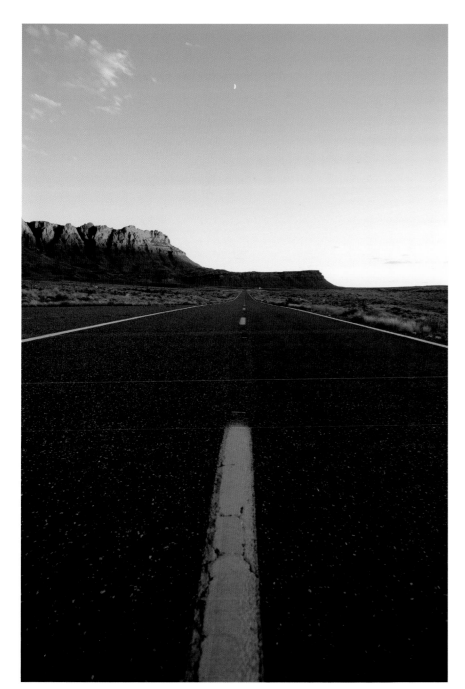

Vermilion Cliffs overview along US 89A en route to the Grand Canyon's North Rim.

Vermilion Cliffs, US 89A

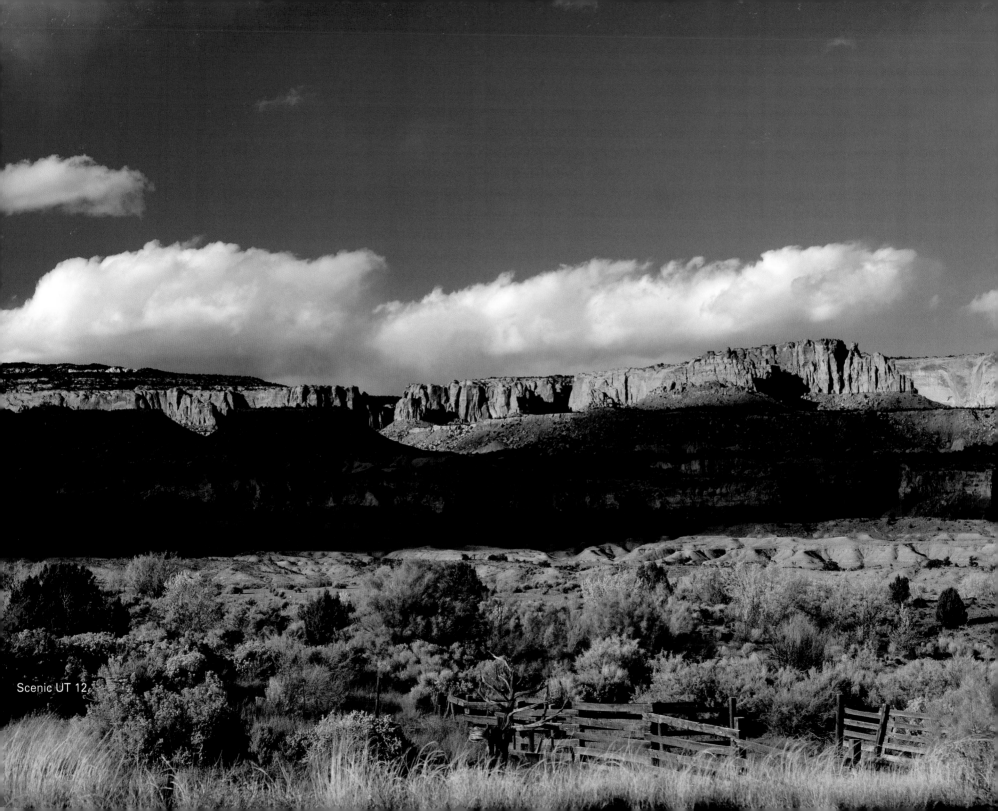

Scenic UT 12

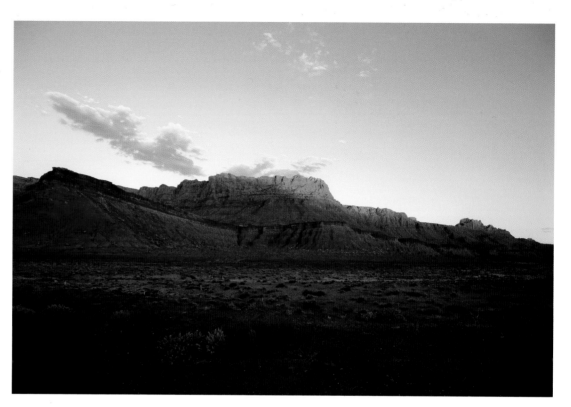

US 89A landscape.

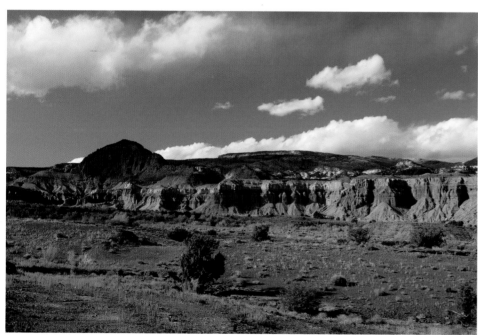

Scenic UT 12.

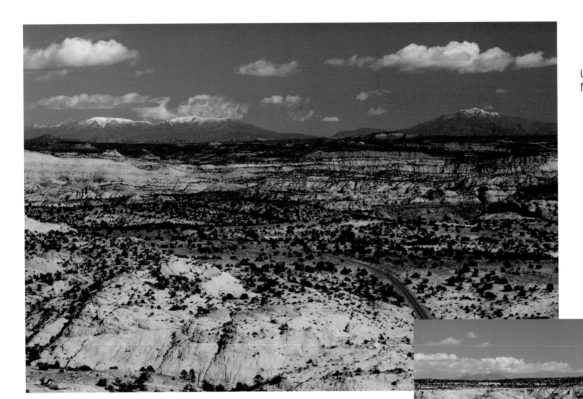

UT 12 curves through the Grand Staircase-Escalante National Monument, with the Henry Mountains in the background.

Fall cottonwoods trace a stream through the Grand Staircase-Escalante National Monument near Boulder Creek, Utah.

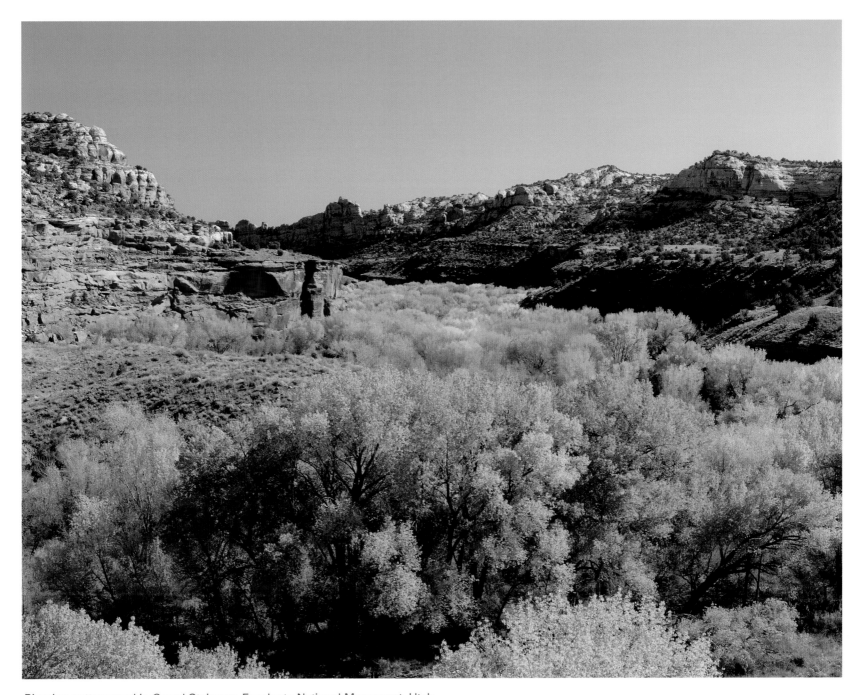

Riparian cottonwood in Grand Staircase-Escalante National Monument, Utah.

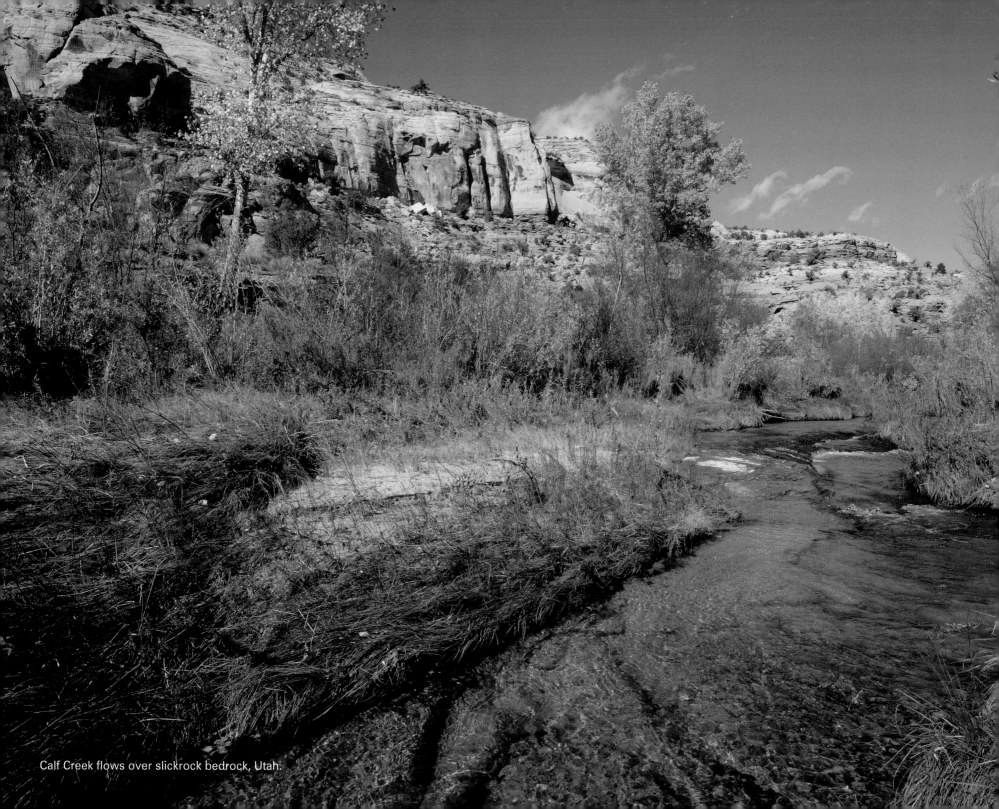

Calf Creek flows over slickrock bedrock, Utah.

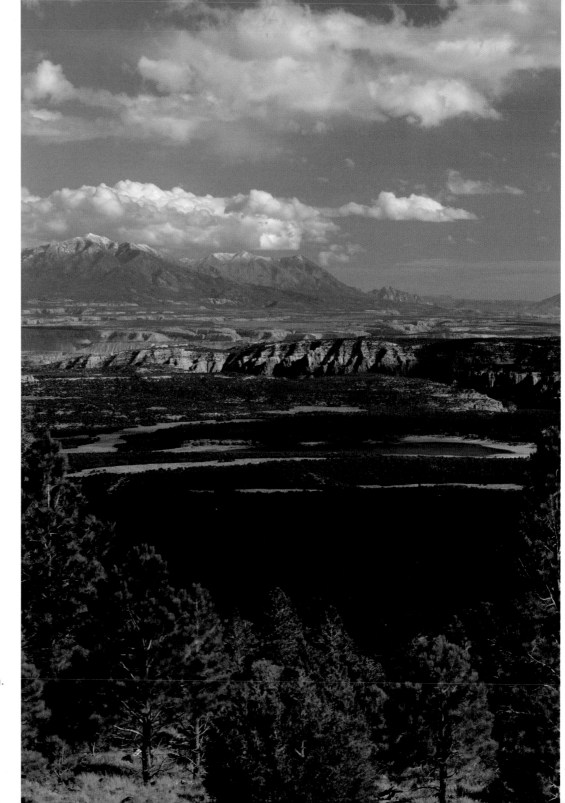

Lower Bowns Reservoir, Utah.

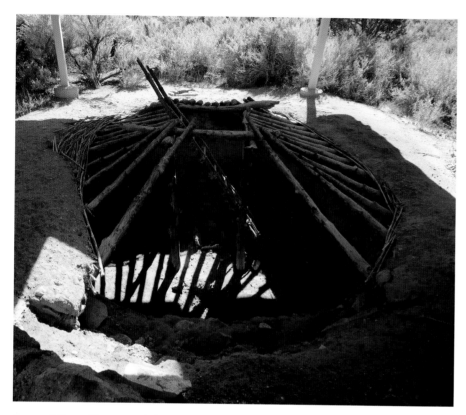

Anasazi State Museum pit house reconstruction in Boulder, Utah. www.stateparks.utah.gov/parks/anasazi

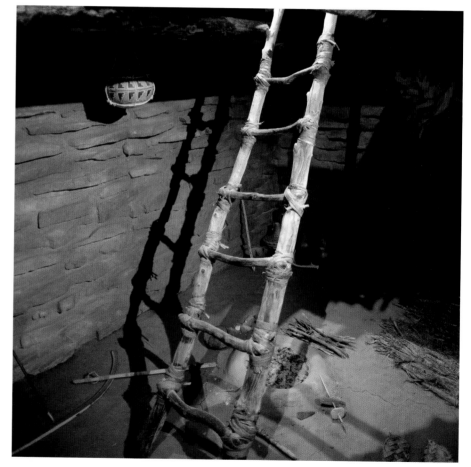

Anasazi State Museum Pueblo room display.

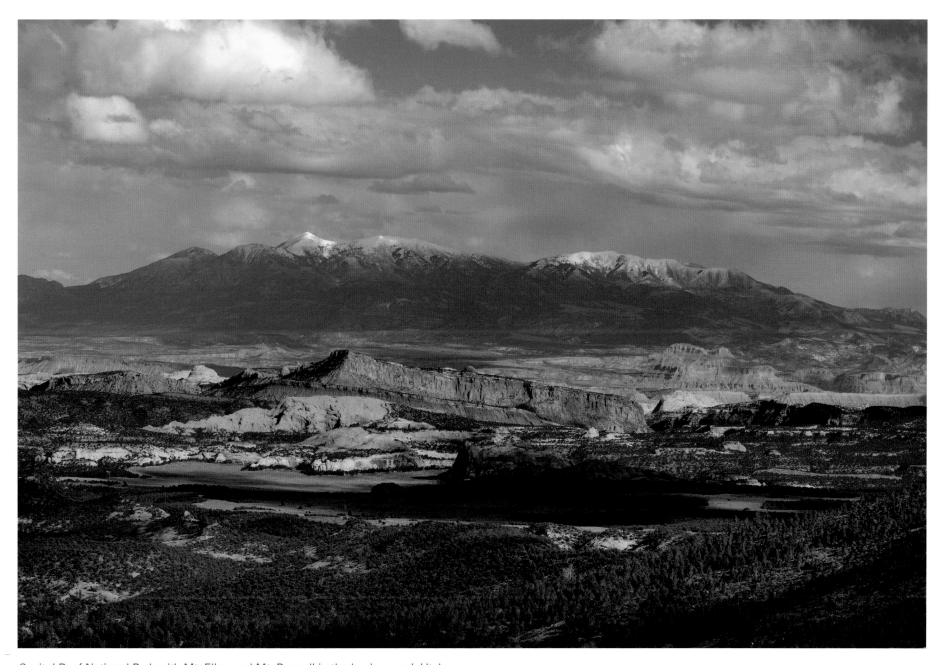

Capitol Reef National Park with Mt. Ellen and Mt. Pennell in the background, Utah.

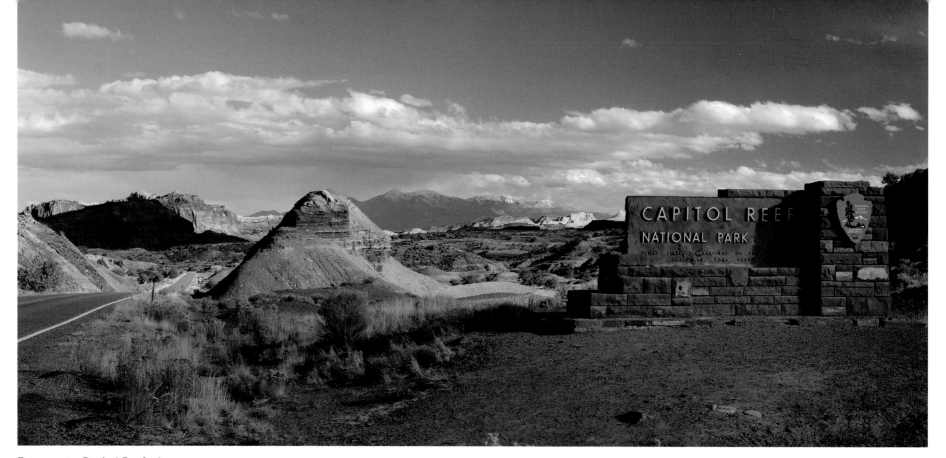

Entrance to Capitol Reef, along UT 24. Capitol Reef National Park protects 378 square miles of colorful canyons, ridges, buttes, and monoliths.

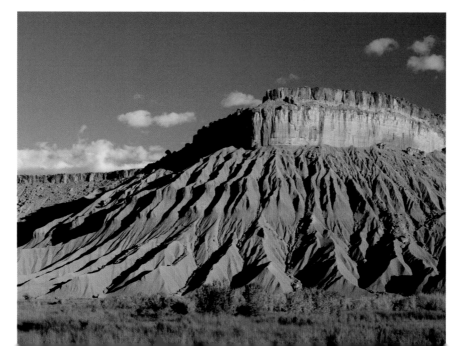

Capitol Reef was once one of the most remote areas in the United States, until UT 24 was constructed in 1962.

Traces of Mormon farming are found throughout Capitol Reef. Settlers found a fertile flood plain in Capitol Reef, which supported many crops and orchards.

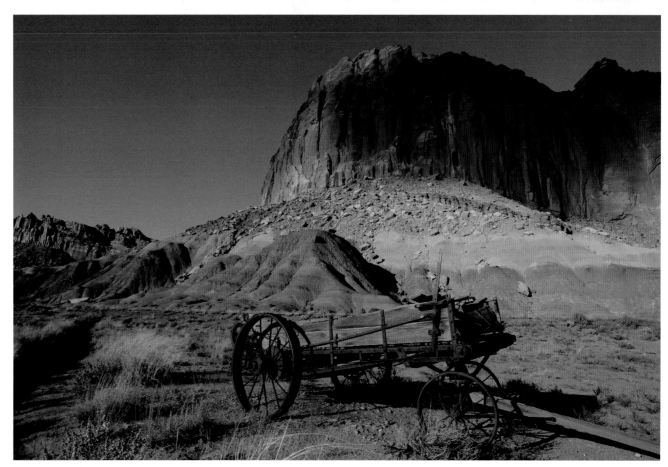

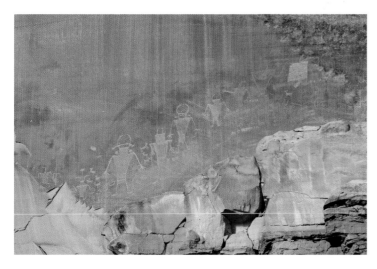

Capitol Reef petroglyphs, left by people of the Fremont Culture in the A.D. 1200s. When settlers arrived in the 1880s, nomadic bands of Ute and Southern Paiute lived in the area.

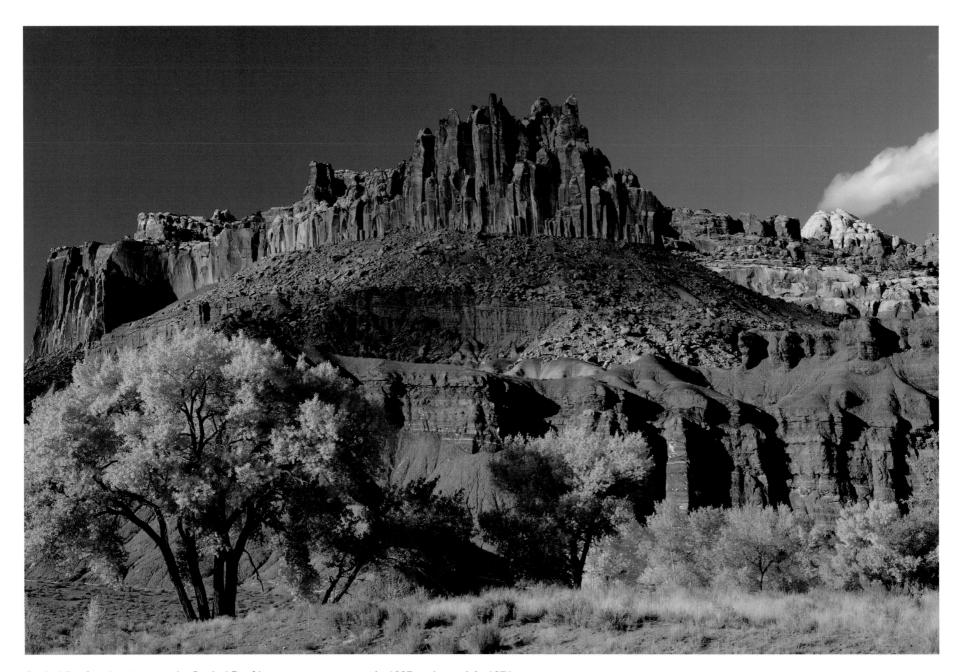

Capitol Reef and cottonwoods. Capitol Reef became a monument in 1937 and a park in 1971.

Scenic UT 24, leaving Capitol Reef National Park, Utah.

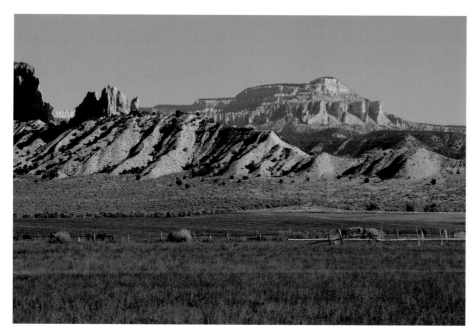

Powell Point from UT 24 in Henrieville. This feature was used by John Wesley Powell to navigate through the area.

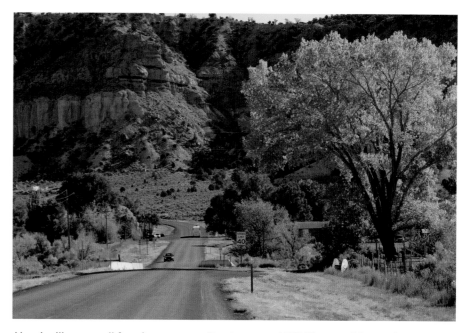

Henrieville, a small farming community along rural UT 12 east of Bryce Canyon.

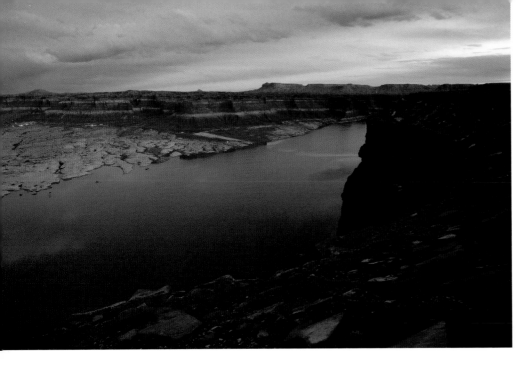

Lake Powell at the north end of Glen Canyon, Utah.

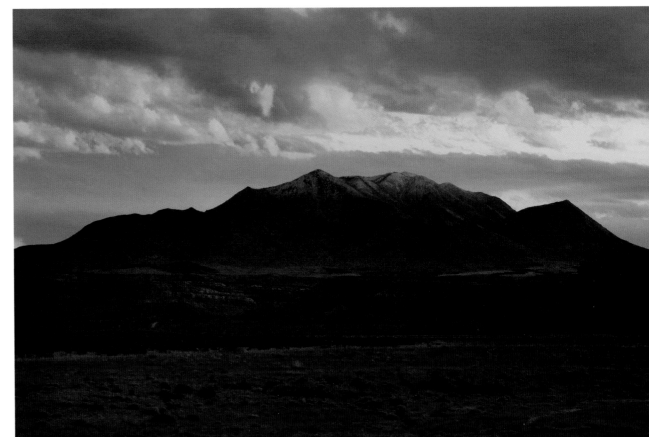

Mt. Ellsworth, part of Utah's Henry Mountains, at sunset.

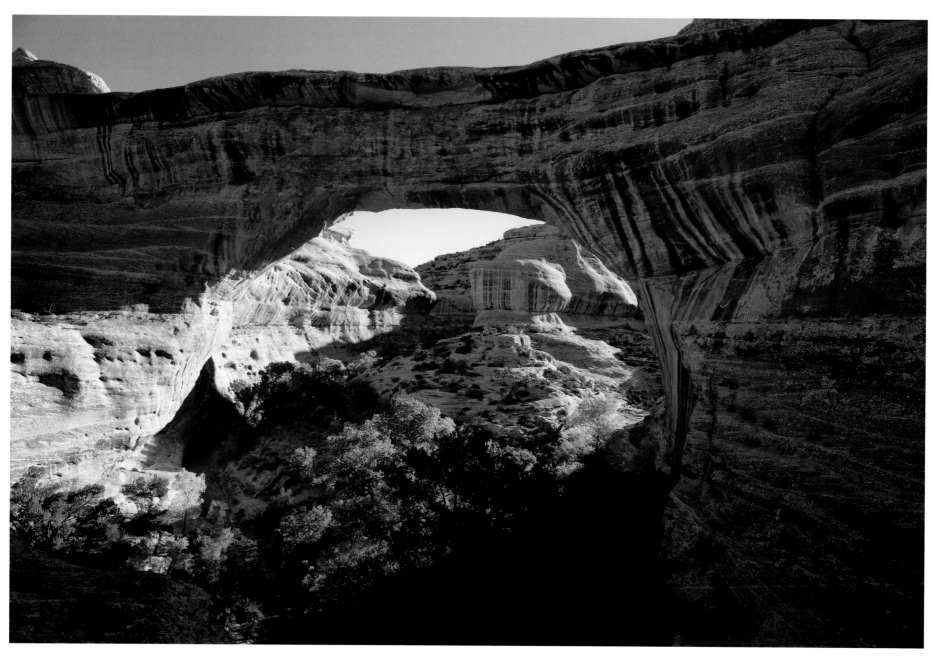

Sipapu Bridge, Natural Bridges National Monument, Utah. The monument protects three impressive natural bridges, Native American ruins, and a desert riparian watershed. National Geographic publicized the area in 1904, and President Theodore Roosevelt declared the site a national monument in 1908. www.nps.gov/nabr/index.htm

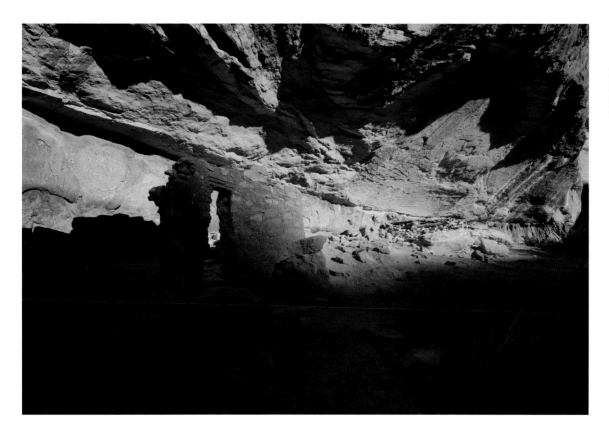

Horsecollar Ruin, reached via a hike from Sipapu Bridge along White Canyon. This was an ancestral pueblo site with ties to today's Hopi. Later, the Navajo would live in the fertile canyon.

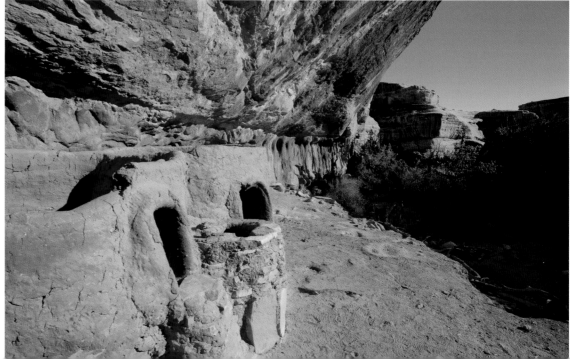

This unique double granary is how Horsecollar Ruin got its name. The shape of its openings is thought to resemble horse collars. Granaries were used to protect grain from rodents and to ensure food throughout the winter and seed for next season's crops.

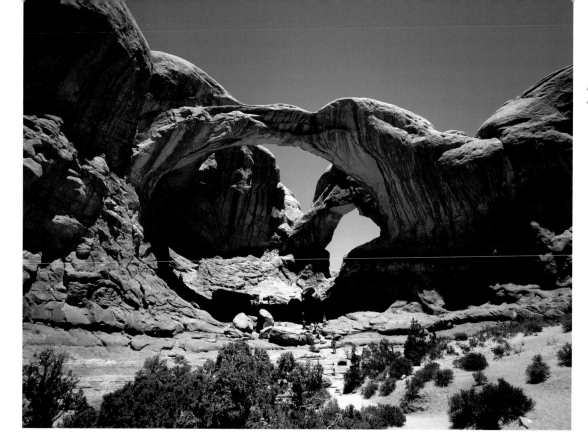

Arches National Park, Double Arch, Utah.

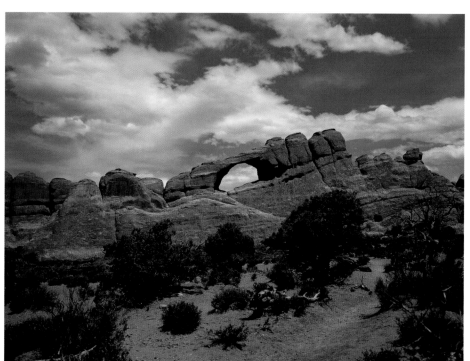

Arches National Park, Skyline Arch, Utah.

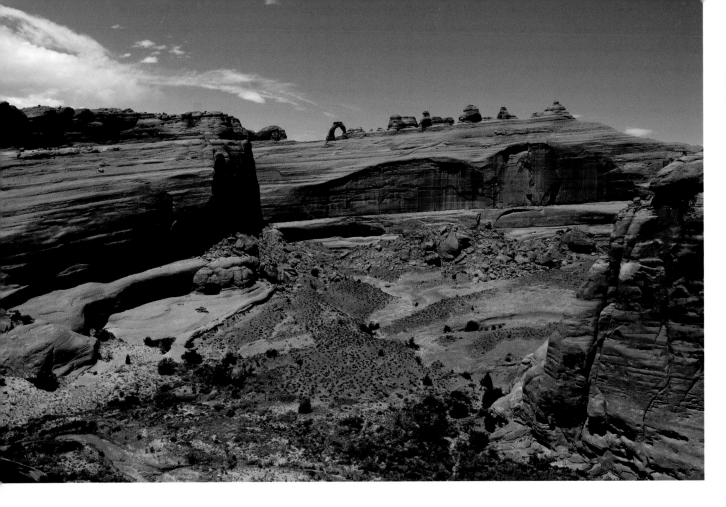

Arches National Park landscape, Utah.
Delicate Arch can be seen near the
middle of the frame.

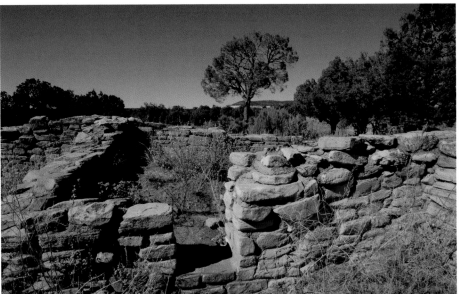

Mule Canyon Ruins sit along UT 95
at mile marker 101.4, 16 miles east of
Natural Bridges National Monument.
This ancestral puebloan site was
occupied in the A.D. 1100s, at the
height of the ancestral puebloan
presence in the Four Corners region.

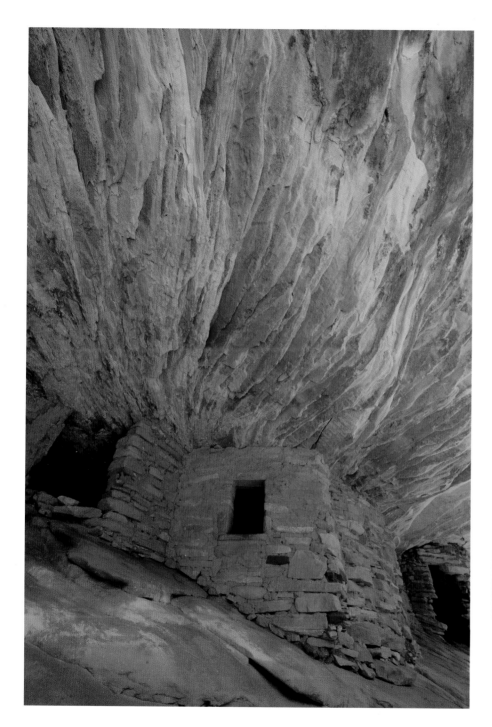

House on Fire is a small ruin in Mule Canyon, reached after a 1.25-mile hike. The trailhead is a third of a mile north on San Juan County Road 263, off of UT 95.

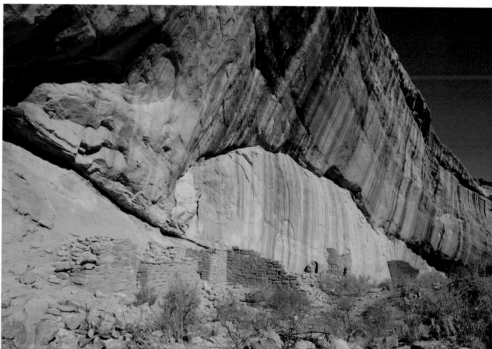

Arch Canyon Ruins, Utah.

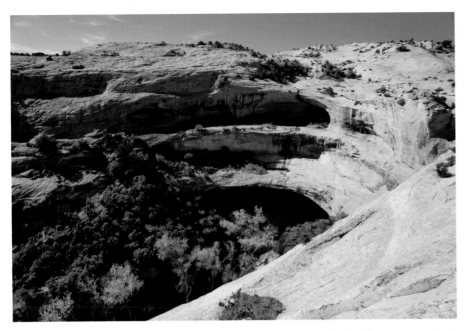

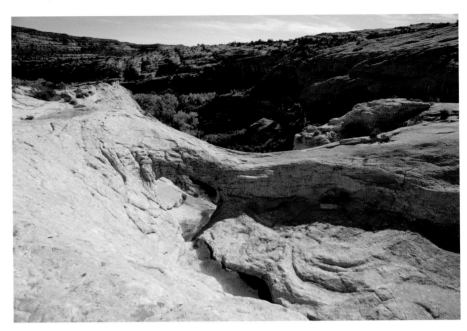

Butler Wash Ruins: These impressive ancestral puebloan cliff dwellings are reached after a fifteen-minute walk across scenic slickrock. The parking area is along UT95, about 11 miles west of the UT 191 intersection. The ruins overlook the north end of Butler Wash, a lush riparian area where water was plentiful. The ruins are situated to take advantage of southern light, and afford protection, as did the cliff dwellings at related Mesa Verde National Park in Colorado, about 70 miles away.

Water collects in this natural cistern at Butler Wash, above the ruins, and flows into the creek below. A small natural bridge has formed where the water flows down the cliff face. This provided the residents of Butler Wash with a fairly dependable water supply during their occupation here.

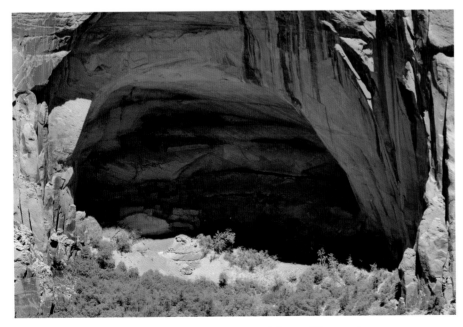

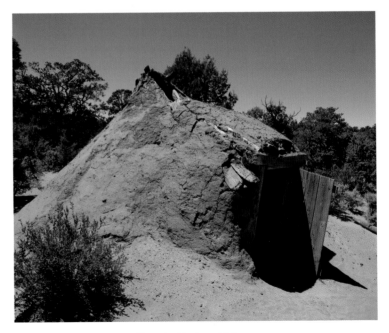

Betatakin Ruins at Navajo National Monument, Arizona. These ruins are ancestral puebloan. www.nps.gov/nava

Navajo male hogan at Navajo National Monument.

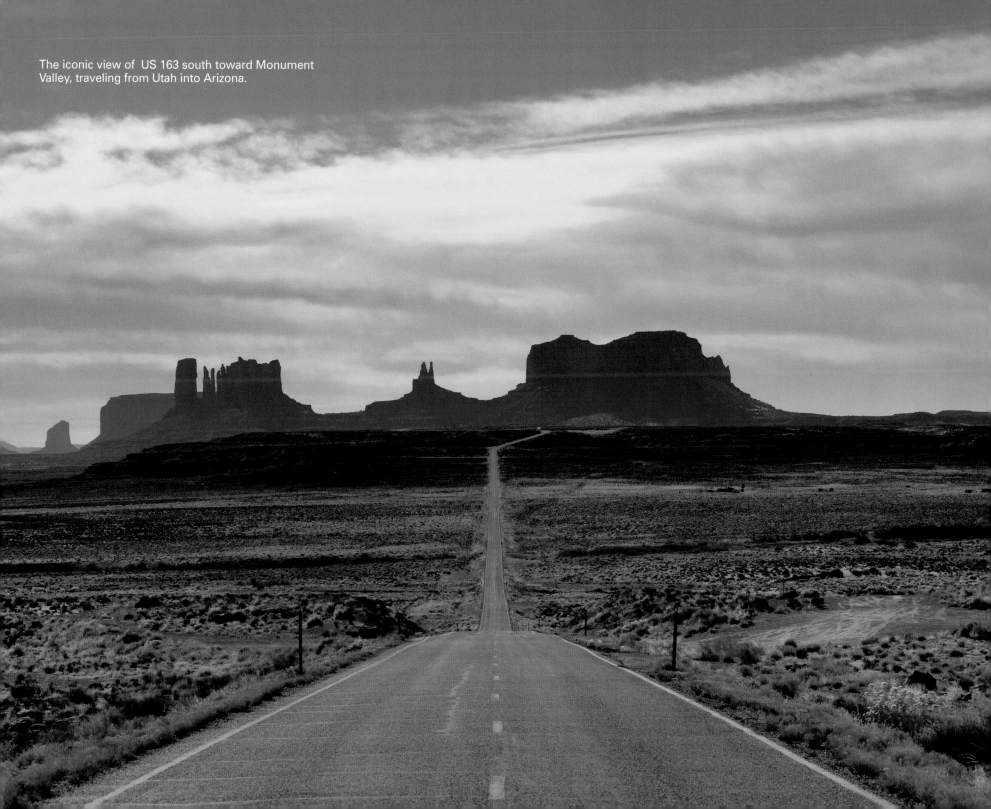
The iconic view of US 163 south toward Monument Valley, traveling from Utah into Arizona.

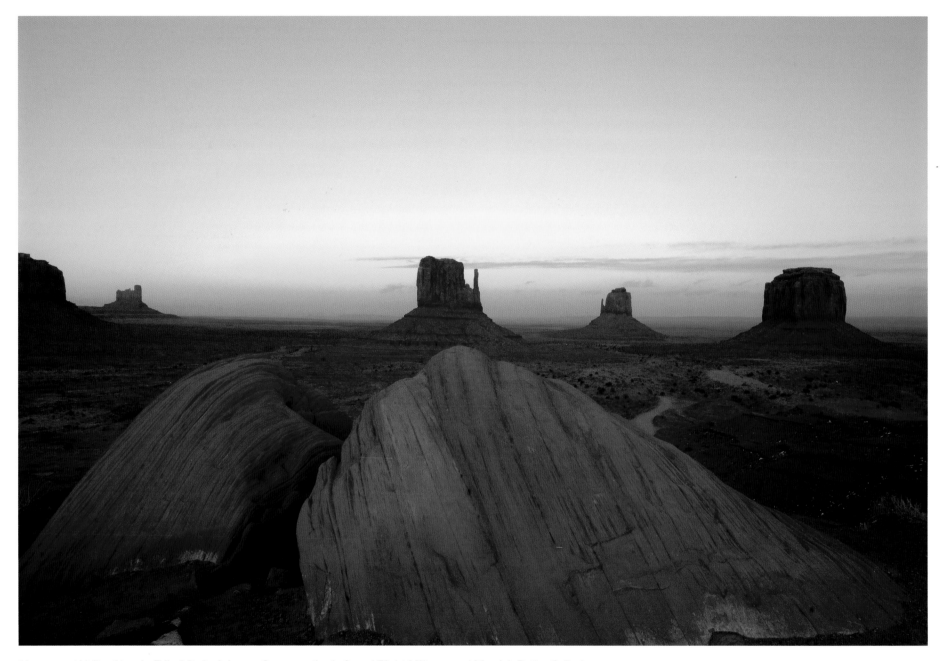

Monument Valley Navajo Tribal Park, Arizona. Seen are the Left and Right Mittens and Merrick Butte. Called Tse'Bii'Ndzisgaii by the Navajo, or Diné, the park is 91,696 acres. Many movies have been filmed here, including 10 movies by western director John Ford, *2001: A Space Odyssey*, *Thelma & Louise,* and *Mission: Impossible II*. The buttes and fantastic formations are held sacred by traditional Navajo, who believe they embody deities from their religion.

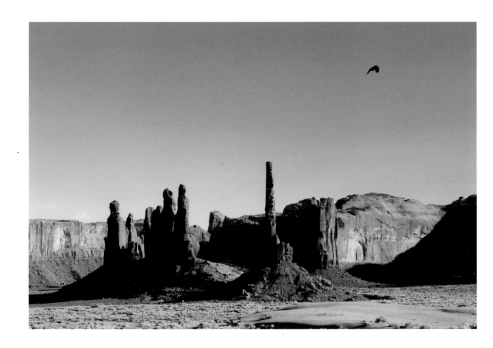

A raven flies above Sand Springs, Totem Pole, and Yei Bi Chei formations at Monument Valley Navajo Tribal Park.

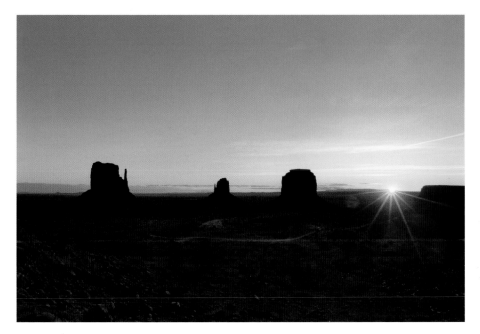

The Left Mitten formation.

Sunrise at Monument Valley.

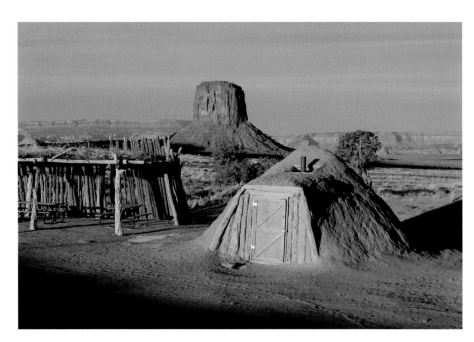

Male Hogan at Monument Valley.

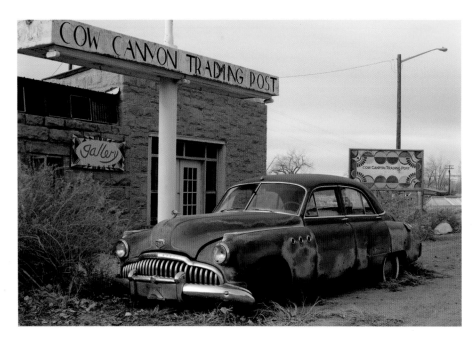

Sand Island Petroglyphs south of Bluff, Utah.

Cow Canyon Trading Post in Bluff, Utah. The car is a 1949 Buick Model 79 Roadmaster.

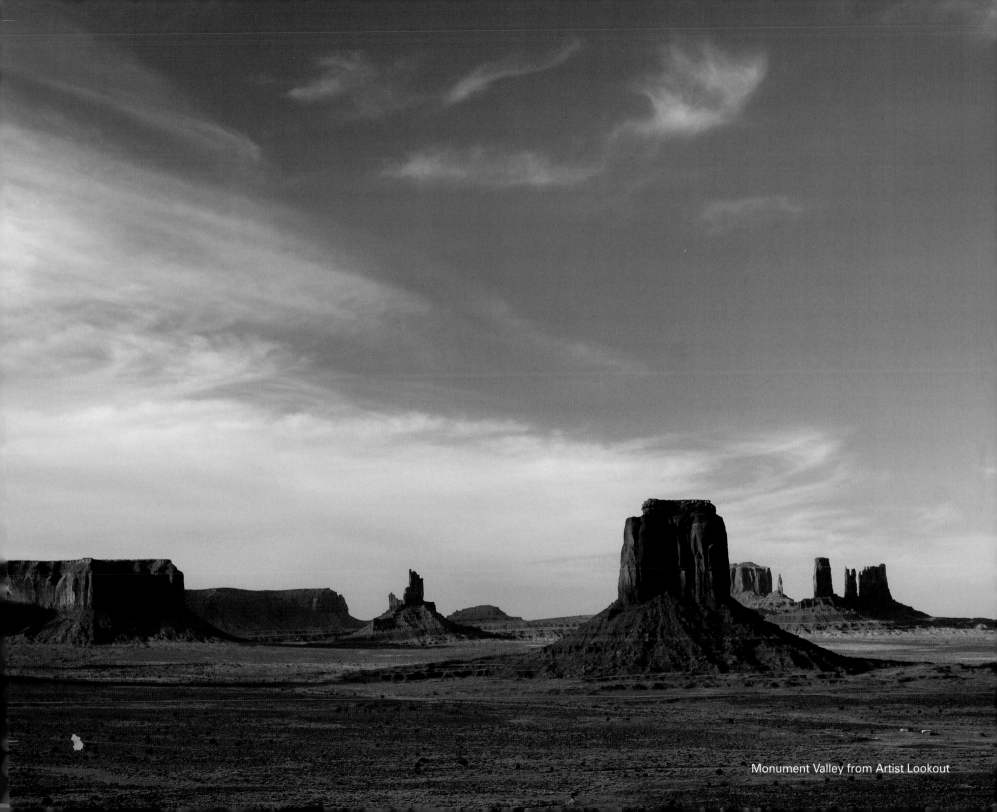

Monument Valley from Artist Lookout

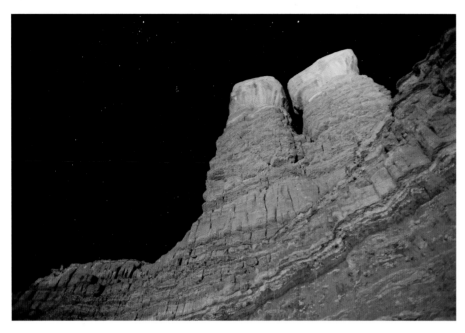

Taurus rises over the Twin Rocks of Bluff, Utah.

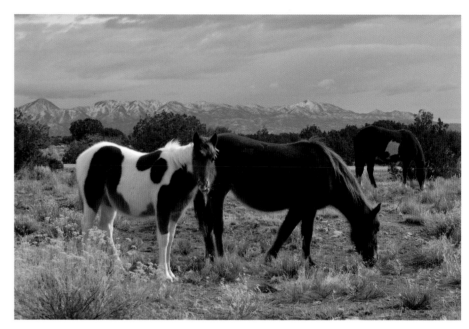

Navajo horses against the San Juan Mountains at Hovenweep National Monument.

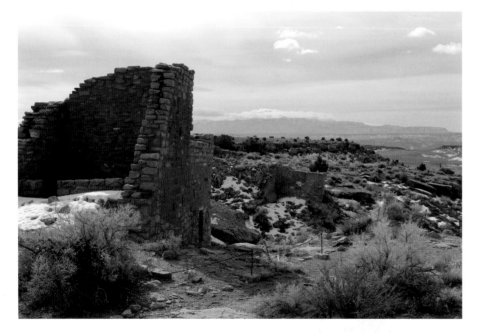

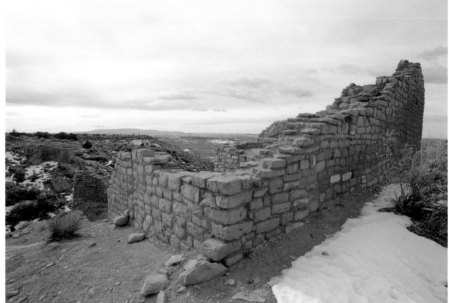

Cajon Ruins Group of Hovenweep National Monument on the Utah and Colorado border. www.nps.gov/hove.

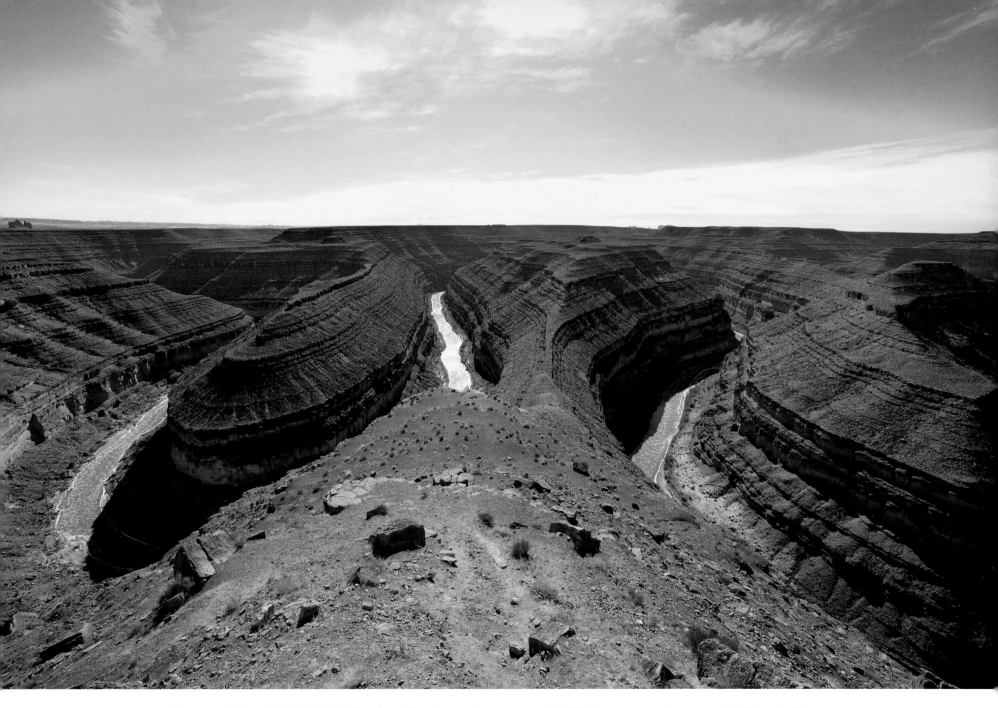

Gooseneck State Park, Utah. The San Juan River has cut its way around 1,000-foot mesas on its way to the Colorado River.

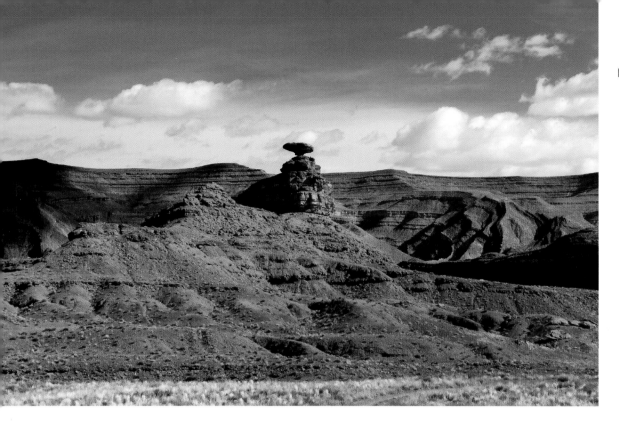

Mexican Hat Rock, for which the town in Utah is named.

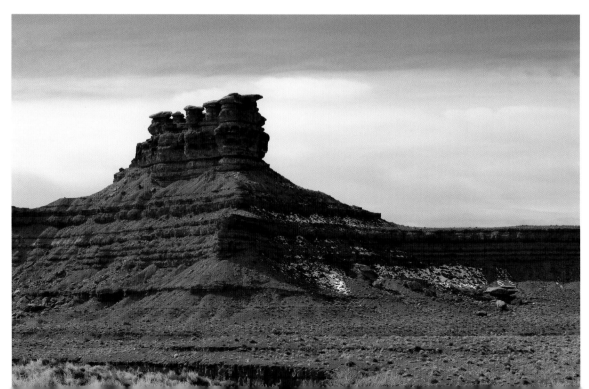

Seven Sailors formation in the Valley of the Gods. A 17-mile dirt road tours through this Bureau of Land Management area north of Monument Valley.

The Four Corners Monument marks the only spot in the United States where four states meet: New Mexico, Arizona, Colorado, and Utah. In 2009, it was discovered that the site is actually 1,807 feet east of where surveyors using equipment today would place the monument (it was established in 1875). However, the US Geodetic Survey states that once a boundary has been officially established, it is legally binding, making the monument site the official center of the Four Corners.

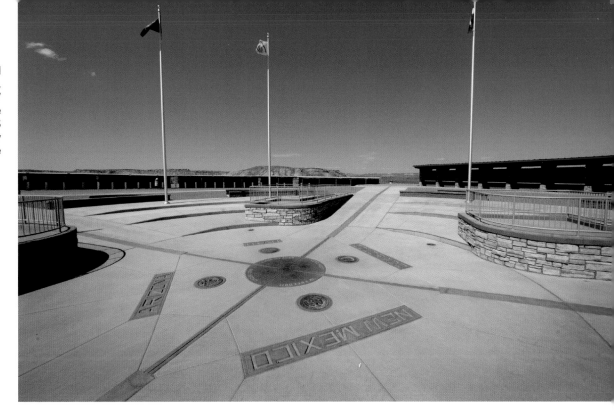

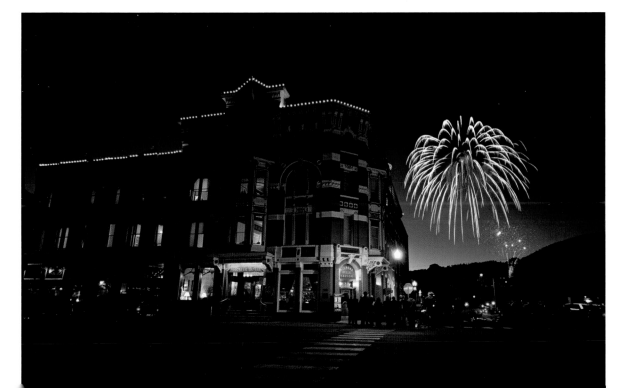

The Strater Hotel in downtown Durango, Colorado.

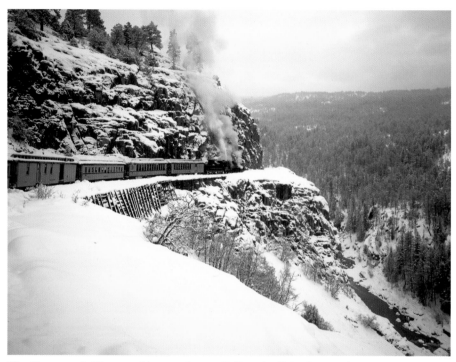

The Durango & Silverton Narrow Gauge Railroad still ferries tourists between Durango and Silverton, Colorado. www.durangosilvertonrailroad.com

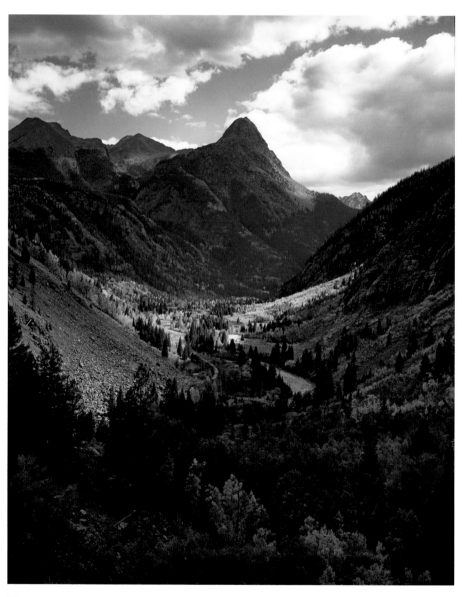

The Durango & Silverton Narrow Gauge Railroad passes through the Weminuche Wilderness below Mt. McKinley in Colorado.

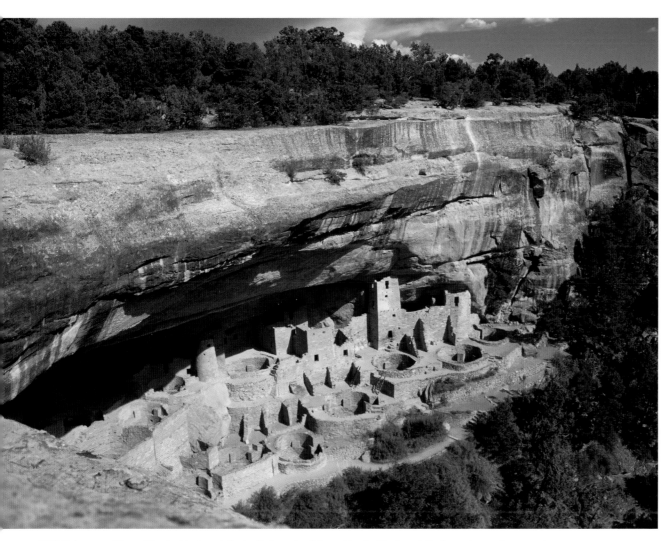

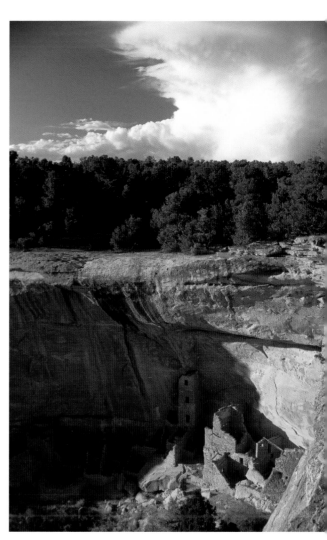

Cliff Palace at Mesa Verde National Park, Colorado. Mesa Verde National Park protects thousands of ancestral puebloan ruins, mostly built between A.D. 600 and 1300. It is the United State's first UNESCO (United Nations Educational, Scientific, and Cultural Organization) World Heritage Site, and was given park status in 1906. www.nps.gov/meve

Square House Ruins, Mesa Verde National Park.

The Anasazi Heritage Museum, in Dolores, Colorado, is the gateway to the Canyons of the Ancients National Monument along the Utah/Colorado border. www.blm.gov/co/st/en/nm/canm.html.

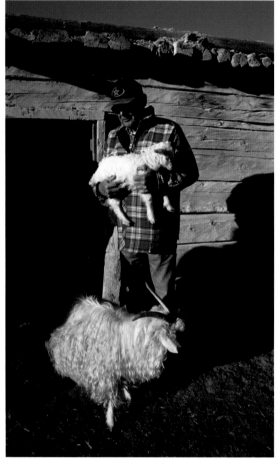

Paul Begay with his churro sheep: Navajos are known for raising fine wool and the exquisite weavings made from it.

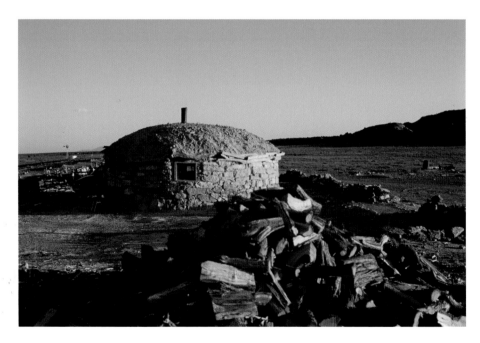

A Navajo Female Hogan being used today. As opposed to the teepee-like male hogans, female hogans are octagonal, with the door always facing east to greet the sun. Traditionally, when Navajo's marry, the husband moves into the wife's hogan.

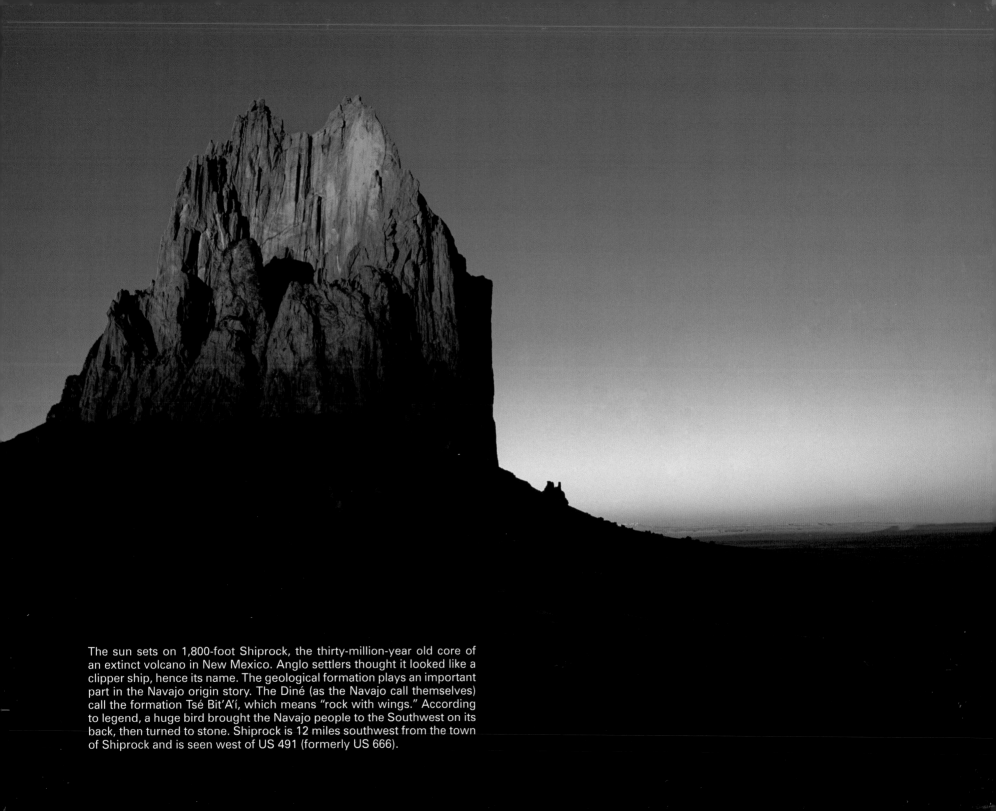

The sun sets on 1,800-foot Shiprock, the thirty-million-year old core of an extinct volcano in New Mexico. Anglo settlers thought it looked like a clipper ship, hence its name. The geological formation plays an important part in the Navajo origin story. The Diné (as the Navajo call themselves) call the formation Tsé Bit'A'í, which means "rock with wings." According to legend, a huge bird brought the Navajo people to the Southwest on its back, then turned to stone. Shiprock is 12 miles southwest from the town of Shiprock and is seen west of US 491 (formerly US 666).

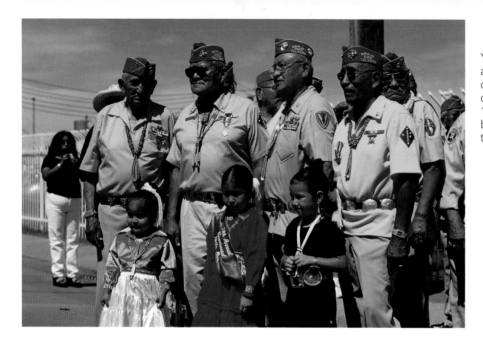

Young Navajo girls pose with Navajo Code Talkers. During World War II, a top-secret program enlisted Navajos into the US Marine Corps, who developed a code based on their language for the Pacific Theater. The code was never broken by the Japanese, and remained classified until 1968. Navajos saw action at Iwo Jima, Guadalcanal, and other major battles. They are credited with saving thousands of American lives by transmitting their code. www.navajocodetalkers.org

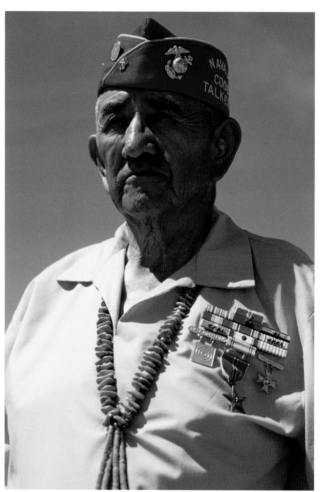

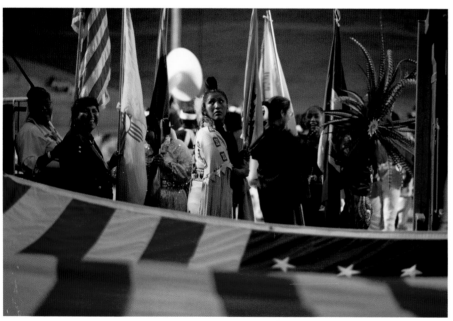

Preparing for the Grand Entry at the Gallup Inter-Tribal Indian Ceremonial, New Mexico. This celebration of Native America sees members of tribes from across the nation gather to share dance, food, art, and culture. It began in 1921. www.theceremonial.com

Navajo Code Talker William Kien served in World War II and Korea, where he was wounded in the leg.

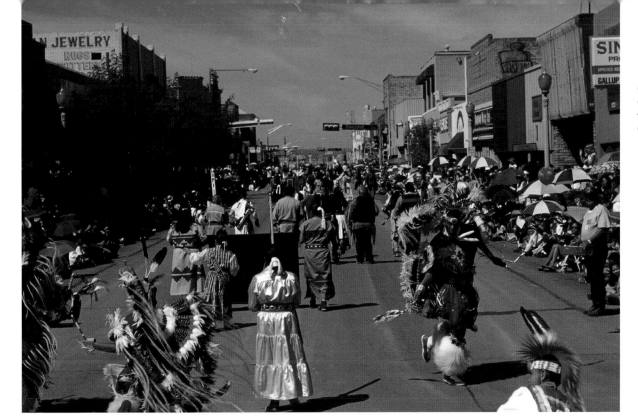

Gallup Inter-Tribal Indian
Ceremonial parade
through downtown
Gallup.

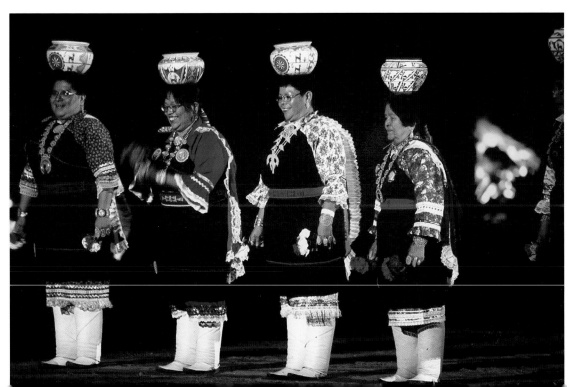

Zuni Olla Maidens dance at
the Gallup Inter-Tribal Indian
Ceremonial.

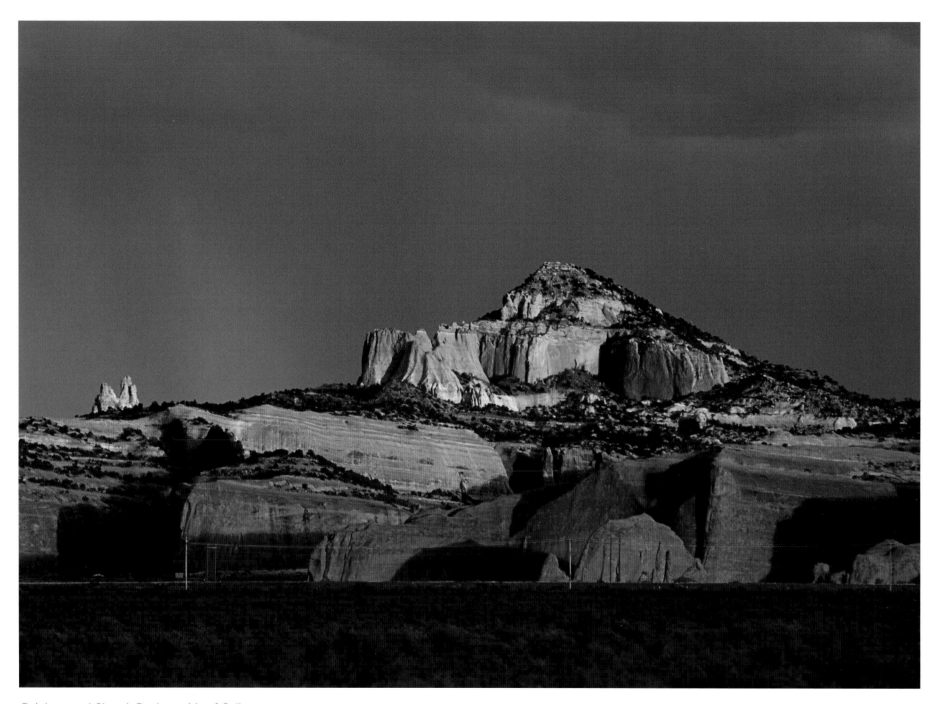

Rainbow and Church Rock outside of Gallup.

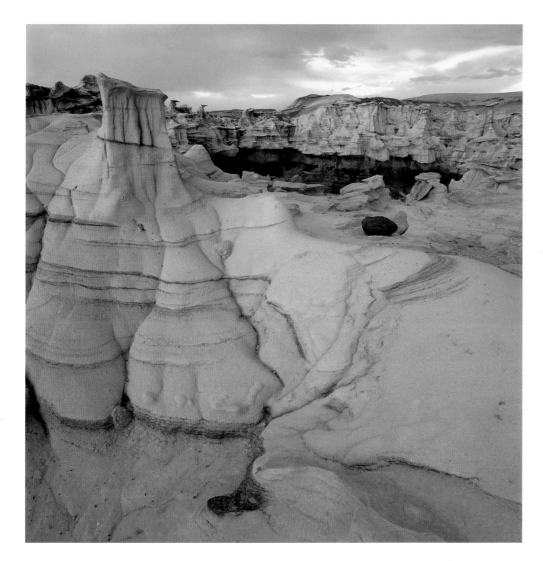

The Bisti/De-Na-Zin Wilderness is 38,305 acres of protected, surreal rock formations south of Farmington, New Mexico. www.blm.gov/nm/st/en/prog/wilderness/bisti.html

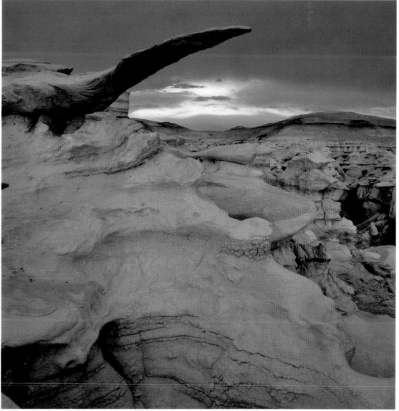

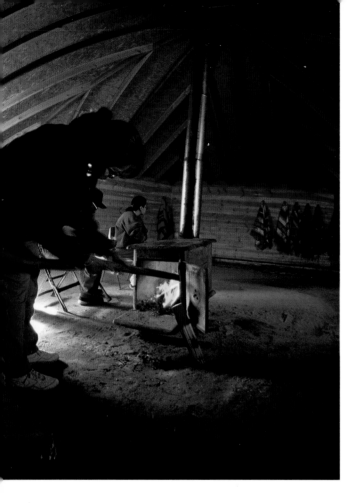

Stoking a wood-burning stove in a hogan, Crystal, New Mexico.

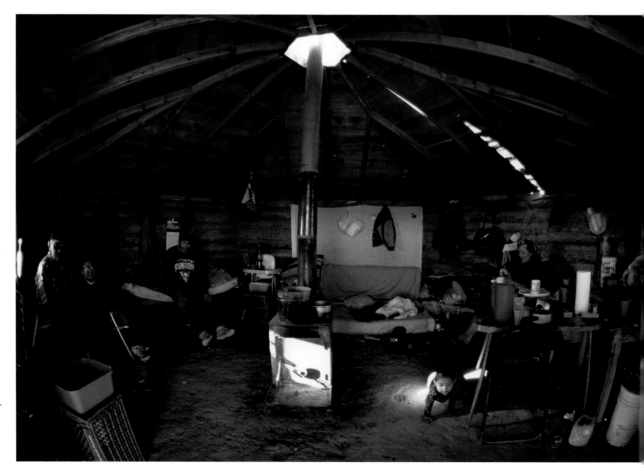

A Navajo family in their hogan, New Mexico.

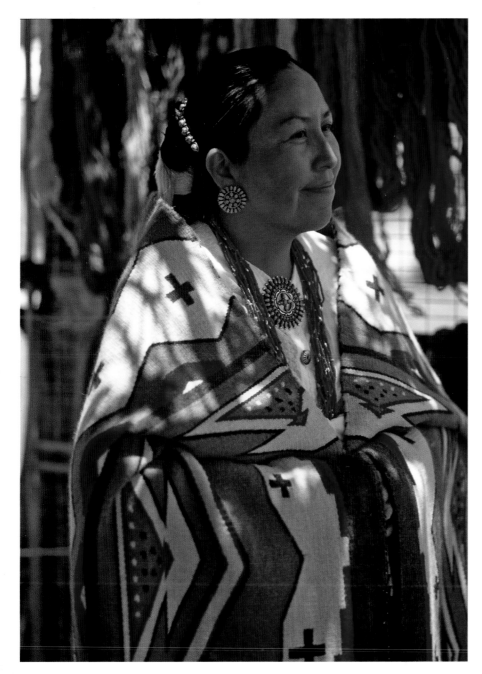

Navajo weaving and jewelry.

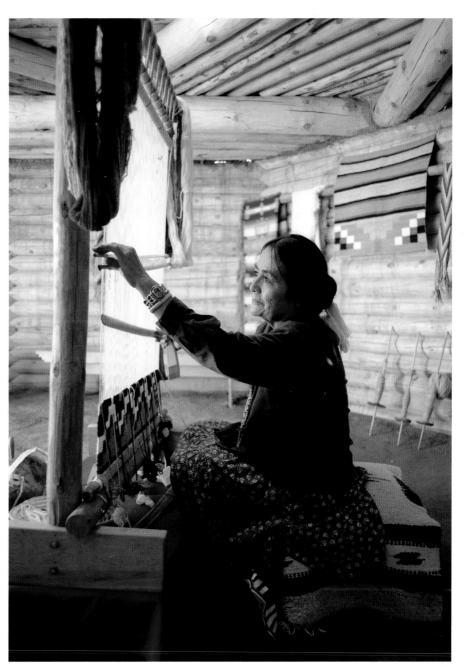

Navajo master weaver Pearl Sunrise.

Navajo women playing string games. These games honor Spider Woman, who in Navajo mythology created the heavens and taught the Diné how to weave.

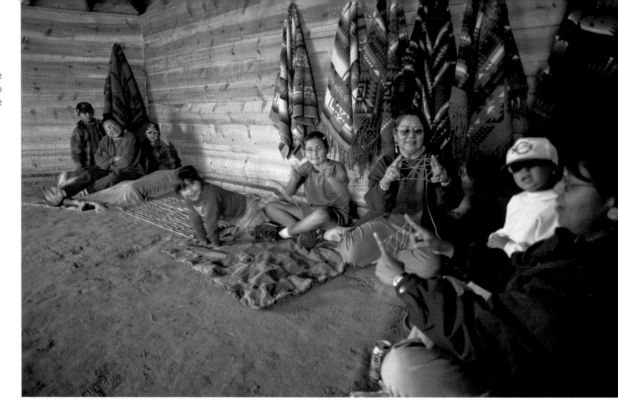

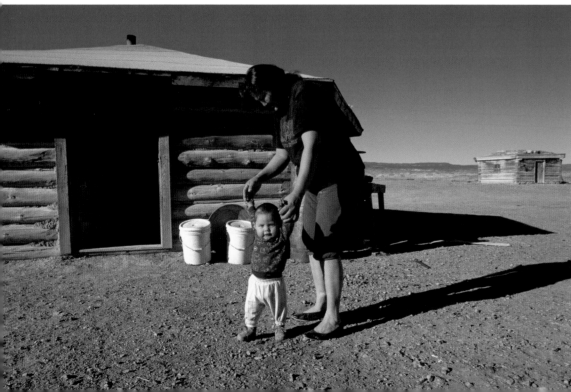

A mother and son play outside of their home, New Mexico.

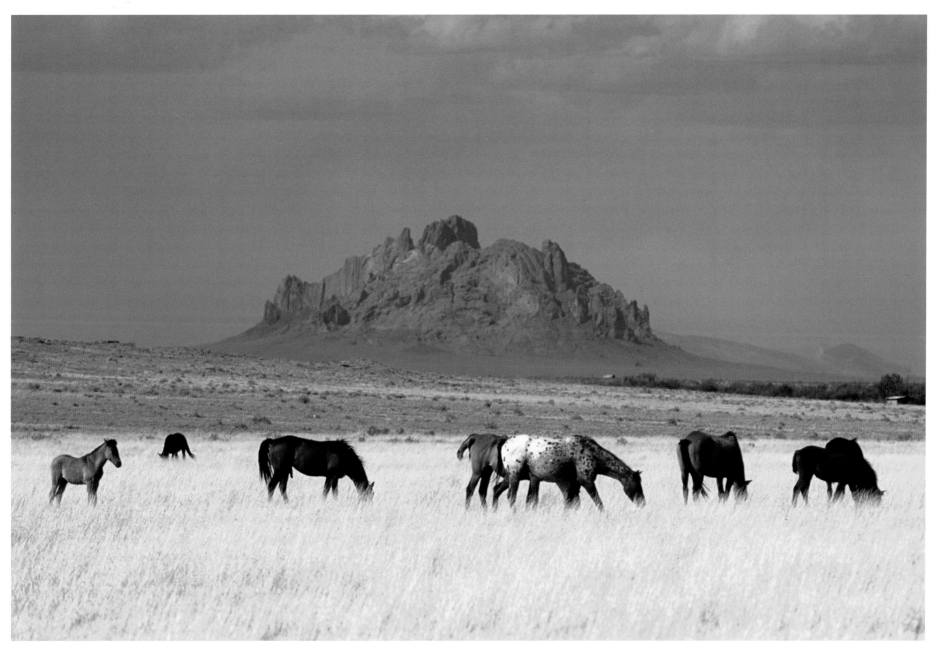

Horses graze with Two Grey Hills in the background near Toadlena, New Mexico.

Two Grey Hills Trading Post and Museum, Toadlena, New Mexico. This trading post and museum supports local Navajo weaving. www.toadlenatradingpost.com

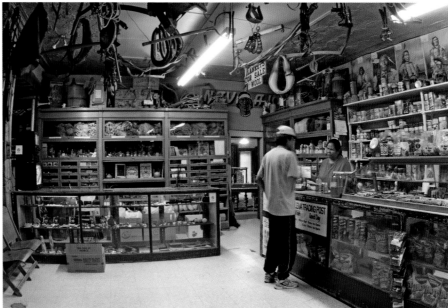

Interior of Two Grey Hills Trading Post.

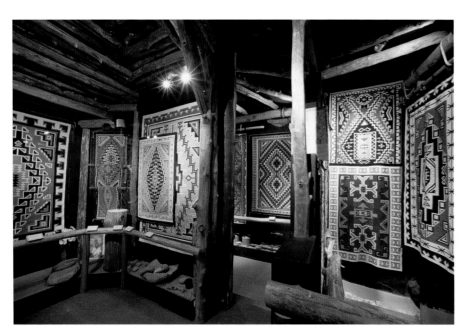

The museum at Two Grey Hills Trading Post.

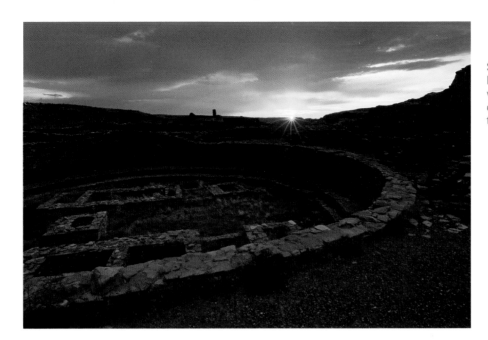

Sunset over Pueblo Bonito at Chaco Culture National Historical Park, New Mexico. Chaco Canyon protects many great houses of the ancestral puebloan world, flourishing between A.D. 850 and 1250. It is thought to have been the center of the ancestral puebloan world, serving as an important spiritual and trading area. www.nps.gov/chcu

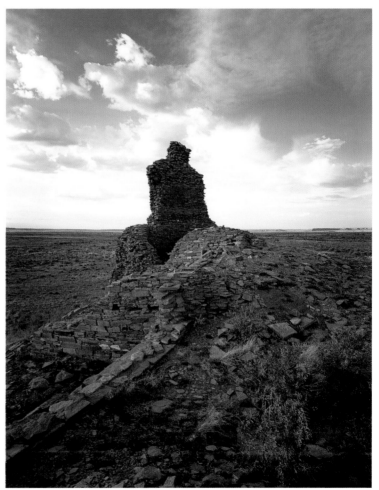

Chaco Canyon outlier Kin Ya'a.

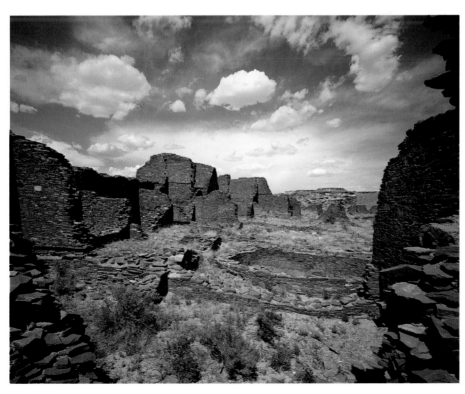

Chaco Canyon outlier Kin Bineola.

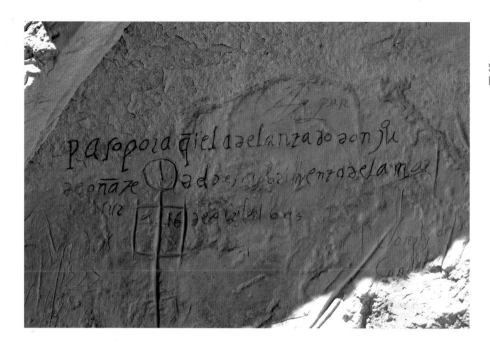

Spanish explorer Don Juan de Oñate's signature at El Morro. It reads "I passed through here."

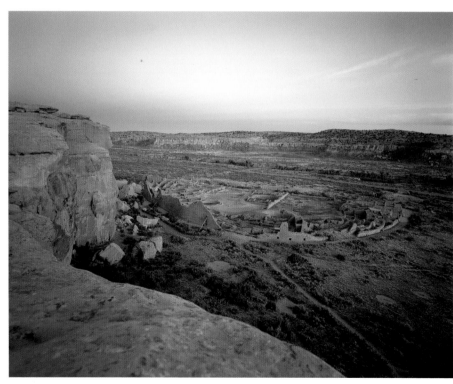

Chaco Canyon's Pueblo Bonito, as viewed from the cliff above it.

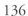

A'ts'ina Ruins atop El Morro at El Morro National Monument, near Grants, New Mexico. www.nps.gov/elmo

El Morro overview.

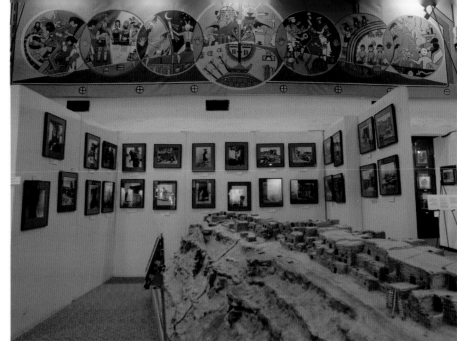

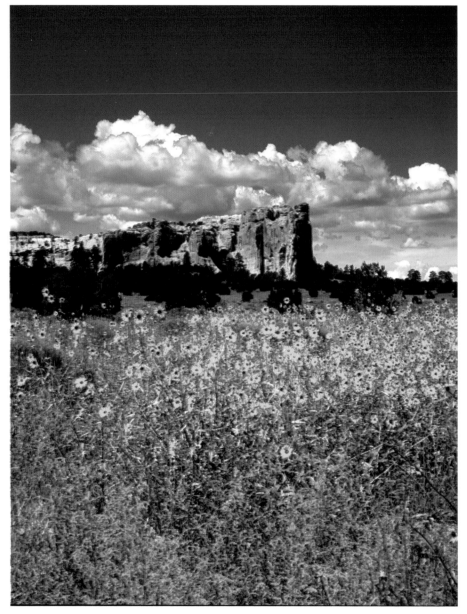

Jerusalem artichokes and El Morro.

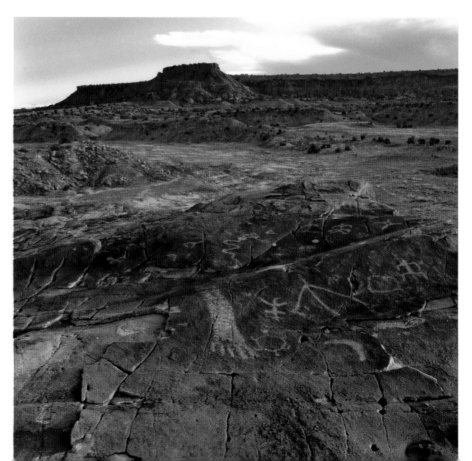

Ojito Wilderness Petroglyphs, near
Zia Pueblo, New Mexico.

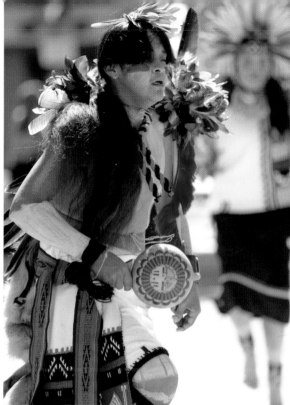

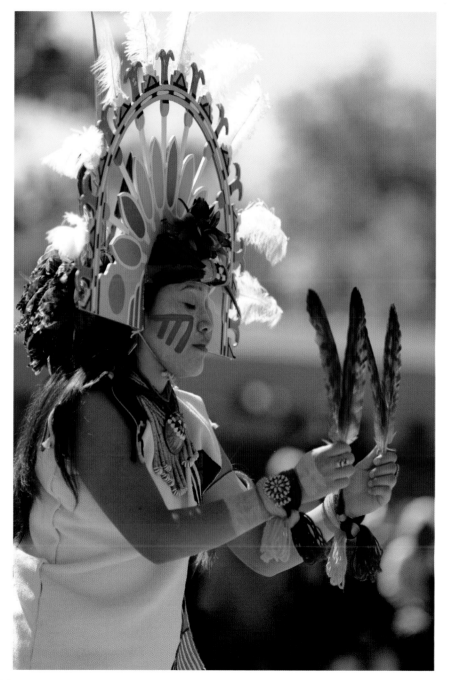

Hopi Dancers of the Red Reed clan.

Hopi artists Garrett and Chelsea Silas and daughter Raelene at their home on Second Mesa. The Hopi call themselves Hopituh Shi-nu-mu, which means "the peaceful people."

White House Ruins, Canyon de Chelly National Monument, near Chinle, Arizona. Canyon de Chelly is where the Navajo escaped to during conflicts with the Spanish, and later, the United States. Navajo tribal members still live and farm within the canyon. Before the arrival of the Navajo, ancestral puebloans built many cliff dwellings throughout the area, of which White House Ruins is the remnant of one.

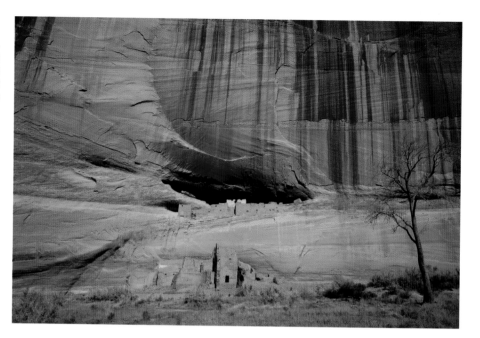

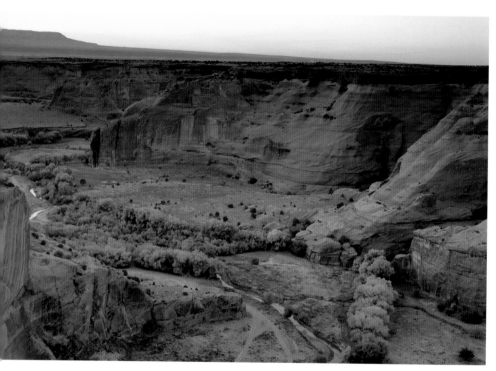

Cottonwoods change color throughout Canyon de Chelly.

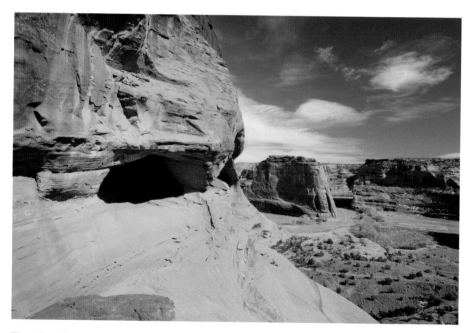

The view from White House Ruins Trail, the only hike within the national monument that doesn't require an accompanying Navajo guide.

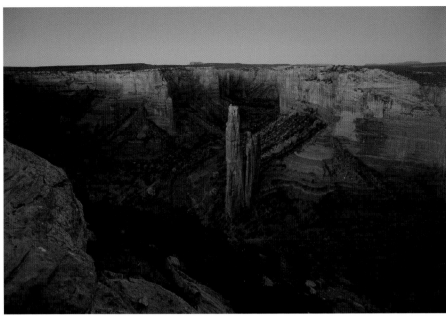

Spider Rock at dusk, Canyon de Chelly. In Navajo mythology, Spider Rock is home to Spider Woman, who created the heavens by weaving a dewy web and throwing it into the sky, where the dew became the stars. She is also credited with teaching the Navajos how to weave.

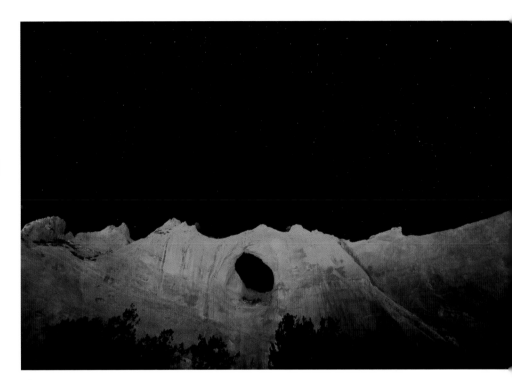

Window Rock and stars, Window Rock, Arizona. The community of Window Rock is the seat of the Navajo Nation Tribal Government, which oversees the West Virginia-sized reservation that encompasses parts of New Mexico, Arizona, and Utah.

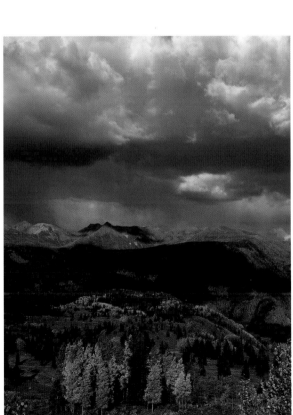

Fall color north of Durango.

141

RESOURCES

Here's a listing by state of major attractions in the Four Corners region. It's always a good idea to call ahead to check weather conditions and room availability before heading out. Gas up whenever possible, and carry food, water and other emergency supplies when driving just in case. AAA's Indian Country Guide Map (ISBN-13: 9781564137067) is an excellent map of the region.

Arizona

Canyon de Chelly National Monument
www.nps.gov/cach
(928) 674-5500

Thunderbird Lodge (Canyon de Chelly Lodging)
Hwy 191 and Rural Rte, Seven
Chinle, AZ 86503
www.tbirdlodge.com
(928) 674-5842

Grand Canyon National Park
www.nps.gov/grca
(928) 638-7888

Grand Canyon Lodge (North Rim, Forever Resorts)
www.grandcanyonlodgenorth.com
(877) 386-4383

Grand Canyon Lodging (South Rim, Xanterra Resorts)
www.grandcanyonlodges.com/
(928) 638-2631

Grand Canyon Railway
www.thetrain.com
1 (800) THE-TRAIN (843-8724)

The Historic Cameron Trading Post
www.camerontradingpost.com/
1 (800) 338-7385

Navajo National Monument
www.nps.gov/nava
(928) 672-2700

Hopi Cultural Center
www.hopiculturalcenter.com
(928) 734-2401

City of Flagstaff
www.flagstaff.az.gov

Glen Canyon National Recreation Area
www.nps.gov/glca
(928) 608-6200

Goulding's Lodge near Monument Valley
www.gouldings.com/
(435) 727-3231

Lowell Observatory
www.lowell.edu
(928) 774-3358

City of Page
www.cityofpage.org

Petrified Forest National Park
www.nps.gov/pefo
(928) 524-6228

Lake Powell
www.lakepowell.com

Montezuma Castle National Monument
www.nps.gov/moca/
(928) 567-3322

Monument Valley Navajo Tribal Park
www.navajonationparks.org/htm/monumentvalley_op.htm
(435) 727-5874

The View Hotel and Restaurant at Monument Valley
www.monumentvalleyview.com
(435) 727-5555

City of Sedona
www.sedonaaz.gov

Tuzigoot National Monument
www.nps.gov/tuzi
(928) 634-5564

Wupakti National Monument
www.nps.gov/wupa
(928) 679-2365

Colorado

Anasazi Heritage Center
www.blm.gov/co/st/en/fo/ahc.html
(970) 882-5600

City of Durango
www.durangogov.org

Hovenweep National Monument
www.nps.gov/hove
(970) 562-4282 ext. 10

Mesa Verde National Park
www.nps.gov/meve
(970) 529-4465

Ute Mountain Tribal Park
www.utemountainute.com
(970) 749-1452

New Mexico

Albuquerque Convention and Visitors Bureau
www.ltsatrip.org

Albuquerque International Sunport
www.cabq.gov/airport

Chaco Culture National Historical Park
www.nps.gov/chcu
(505) 786-7014 ext. 221

Gallup Inter-tribal Indian Ceremonial
www.theceremonial.com
(505) 863-3896

City of Farmington
www.fmtn.org/
(505) 327-7701

Aztec Ruins National Monument
www.nps.gov/azru
(505) 334-6174 ext. 230

Salmon Ruins
www.salmonruins.com/
(505) 632-2013

The Four Corners Monument
www.navajonationparks.org/htm/fourcorners.htm

Bisti/De-Na-Zin Wilderness
www.blm.gov/nm/st/en/prog/wilderness/bisti.html

Navajo Nation Tourism Department
www.discovernavajo.com/

Two Grey Hills Trading Post and Museum
www.toadlenatradingpost.com
(888) 420-0005

El Morro National Monument
www.nps.gov/elmo/index.htm
(505) 783-4226 ext. 0

Utah

Anasazi State Museum
www.stateparks.utah.gov/parks/Anasazi
(435) 335-7308

Arches National Park
www.nps.gov/arch
(435) 719-2299

Town of Bluff
www.bluffutah.org

Bryce Canyon National Park
www.nps.gov/brca
(435) 834-5322

Canyonlands National Park
www.nps.gov/cany
(435) 719-2313

Capitol Reef National Park
www.nps.gov/care
(435) 425-3791 ext. 4111

Gooseneck State Park
www.utah.com/stateparks/goosenecks.htm
(435) 678-2238

Natural Bridges National Monument
www.nps.gov/nabr
(435) 692-1234 ext. 16

Utah State Tourism
www.Utah.com

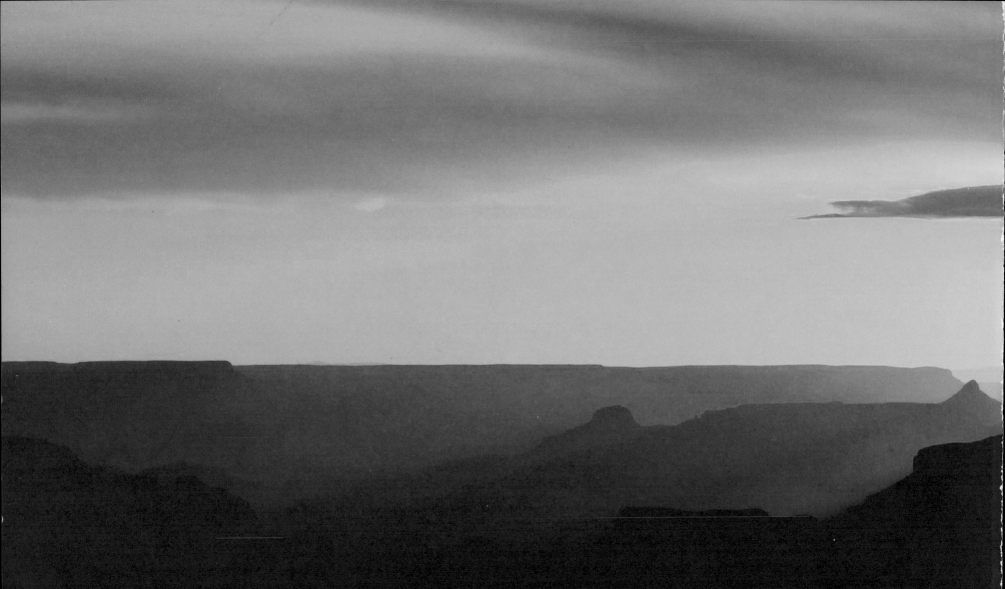